Masterpieces of Goya (1909)

ISBN-13 : 978-1512339406
ISBN-10 : 1512339407

Copyright©2012-2014 Iacob Adrian
All Rights Reserved.

Notice

This documentary study use historic, archived documents.

Because of this, some pages may look blurry or low quality.

Still are included in this book because they have

high value from critical, documentary, historical,

informative and journalistic point of view .

Dtp and visual art

Iacob Adrian

THE

MASTERPIECES

OF

GOYA

(1746-1828)

Sixty reproductions of photographs from the original paintings, affording examples of the different characteristics of the Artist's work

Author statement

This is a series of art books.

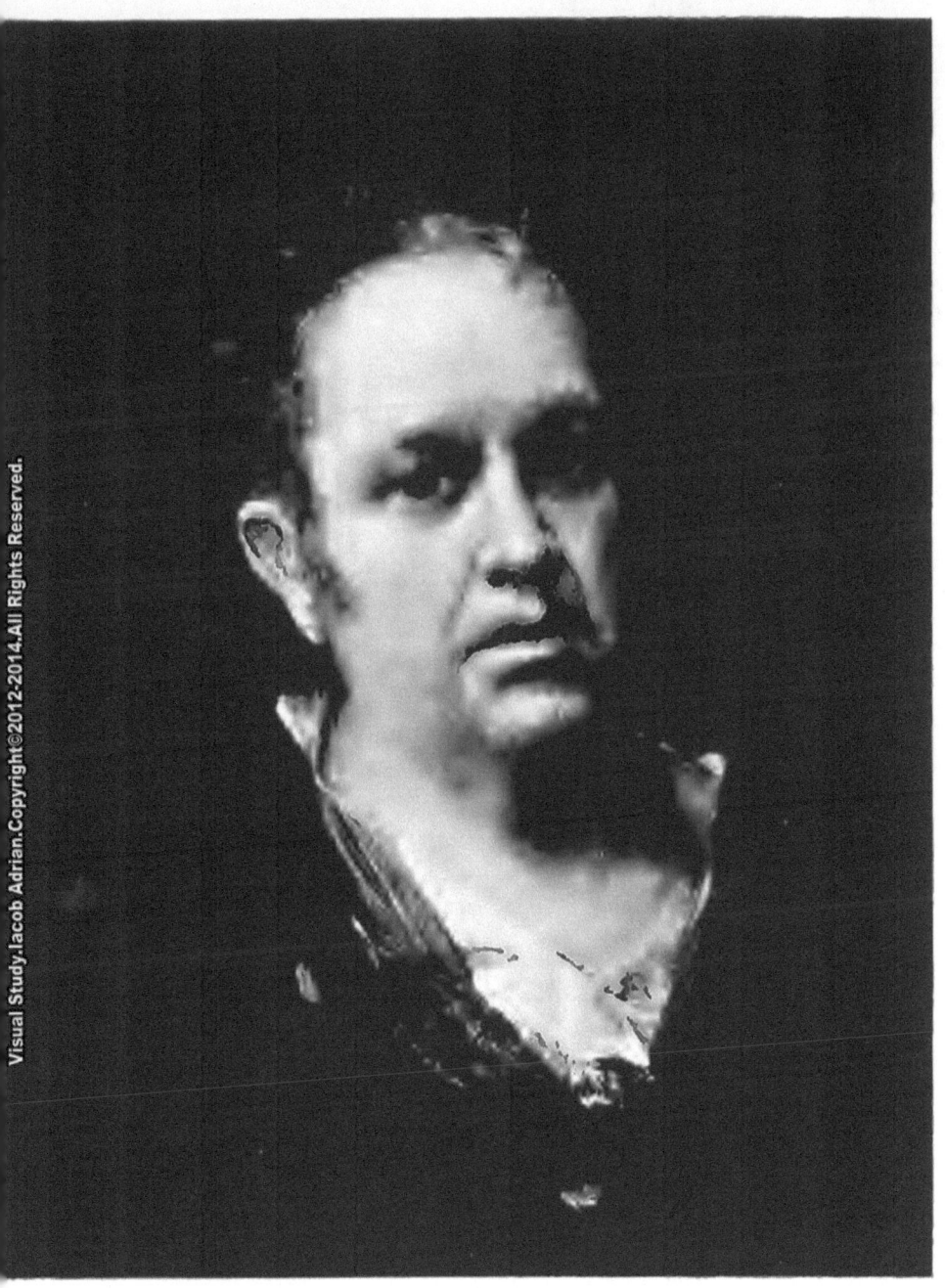

PORTRAIT OF HIMSELF
(*Prado, Madrid*)

PORTRAIT DE L'ARTISTE
(*Prado, Madrid*)

SELBSTBILDNIS
(*Madrid, Prado*)
D. Anderson, Photo.

This little Book conveys the greetings of

..

to

..

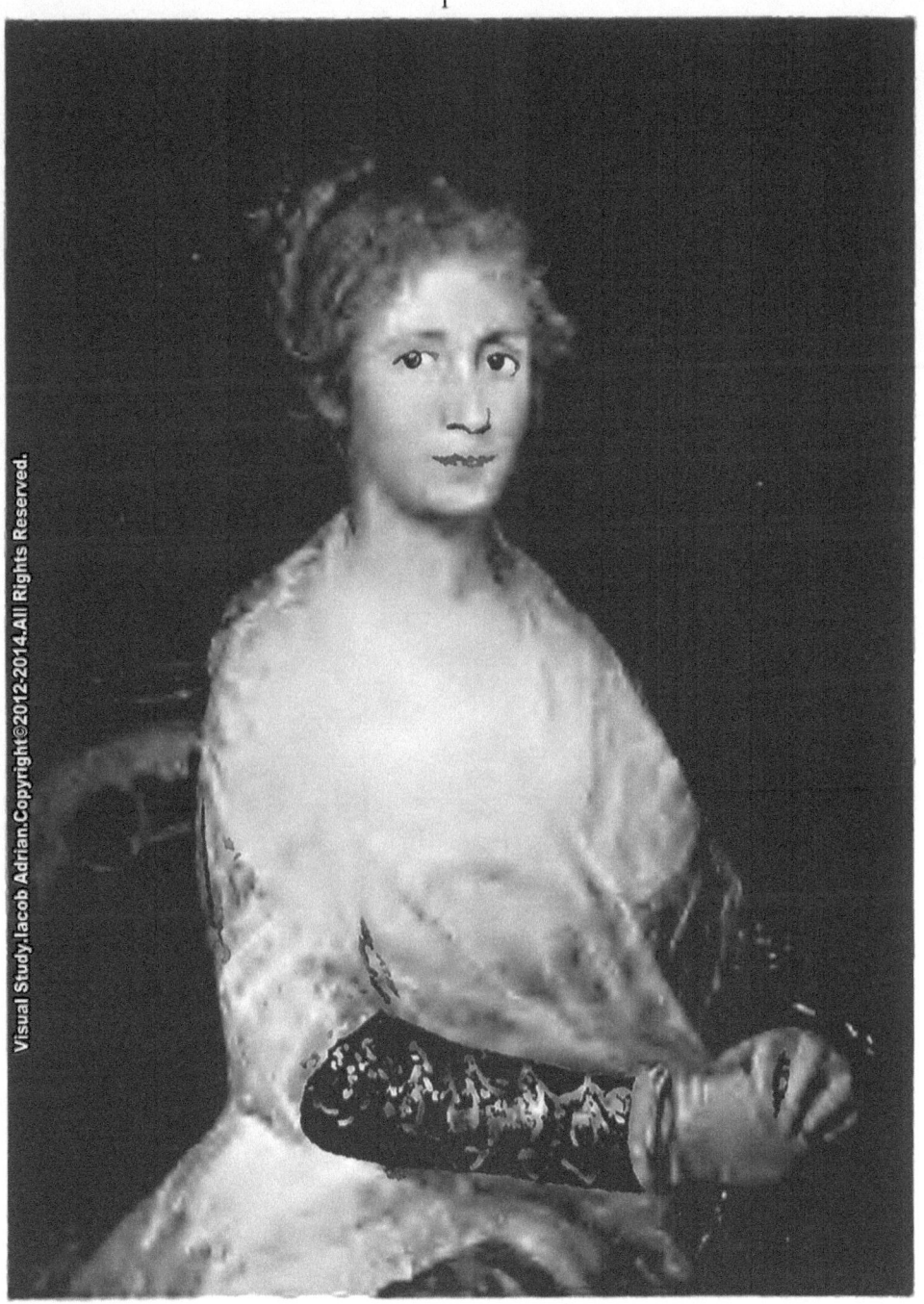

JOSEFA BAYEU (GOYA'S WIFE) JOSEFA BAYEU (FEMME DE GOYA)
(*Prado, Madrid*) (*Prado, Madrid*)
JOSEFA BAYEU (GOYAS FRAU)
(*Madrid, Prado*)
F. Hanfstaengl, Photo.

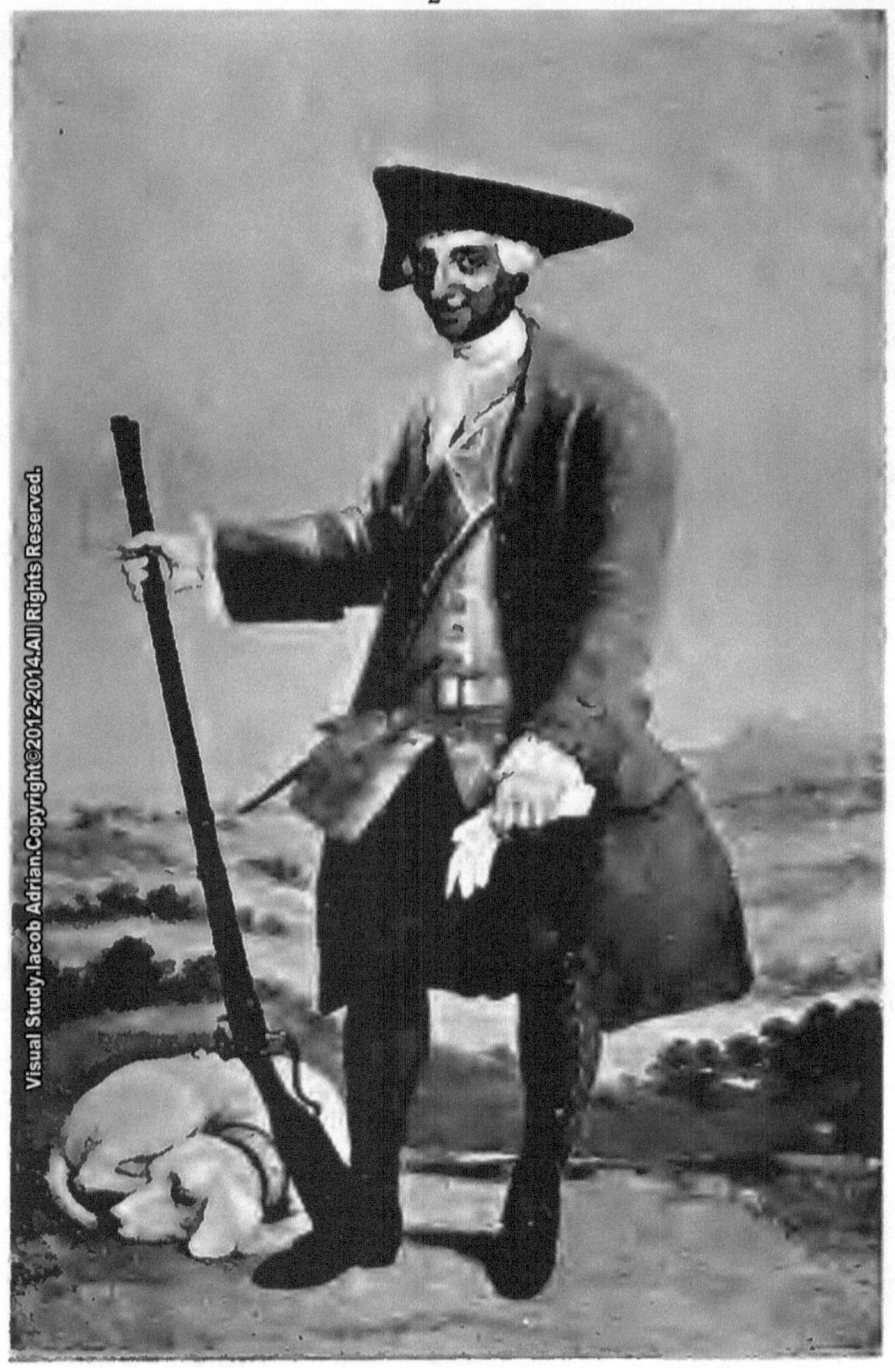

KING CHARLES III.
(Prado, Madrid)

LE ROI CHARLES III.
(Prado, Madrid)

KÖNIG KARL III.
(Madrid, Prado)

Lévy et son Fils, Photo.

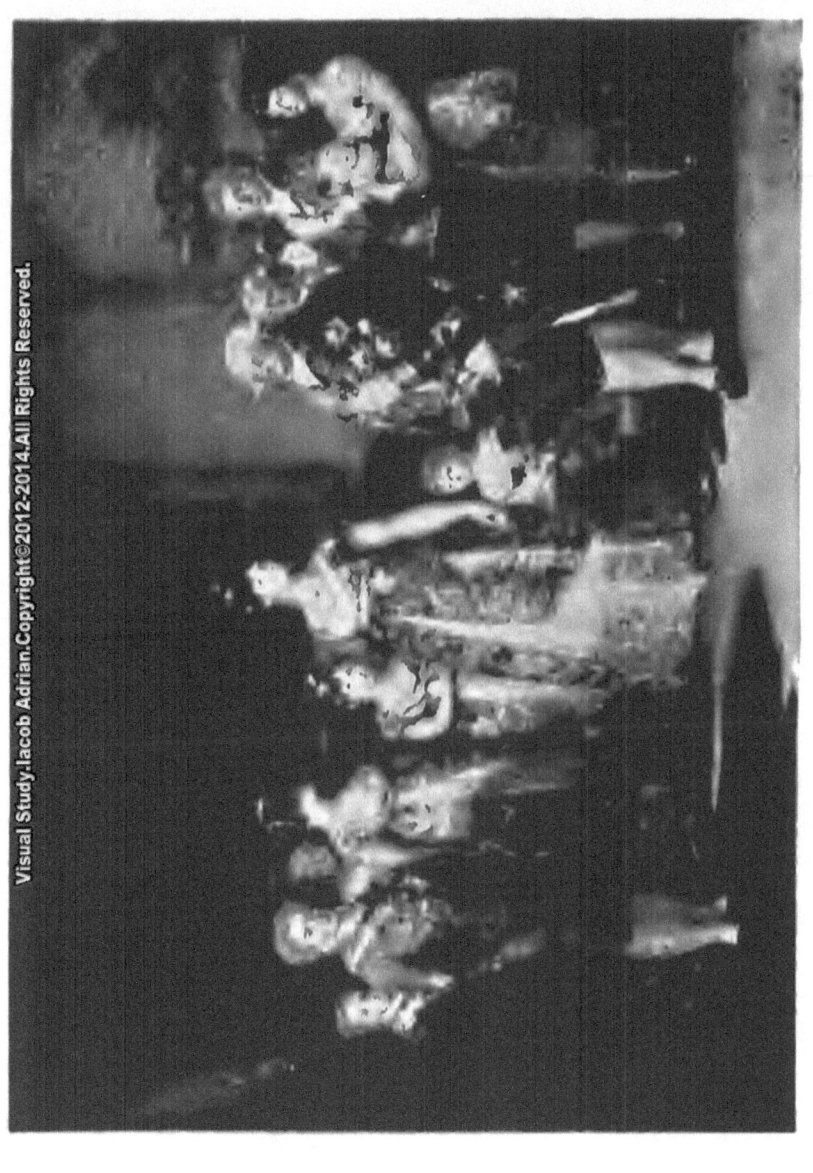

THE FAMILY OF CHARLES IV. LA FAMILLE DE CHARLES IV.
(Prado, Madrid) (Prado, Madrid)
DIE FAMILIE KARLS IV. F. Hanfstaengl, Photo.
(Madrid, Prado)

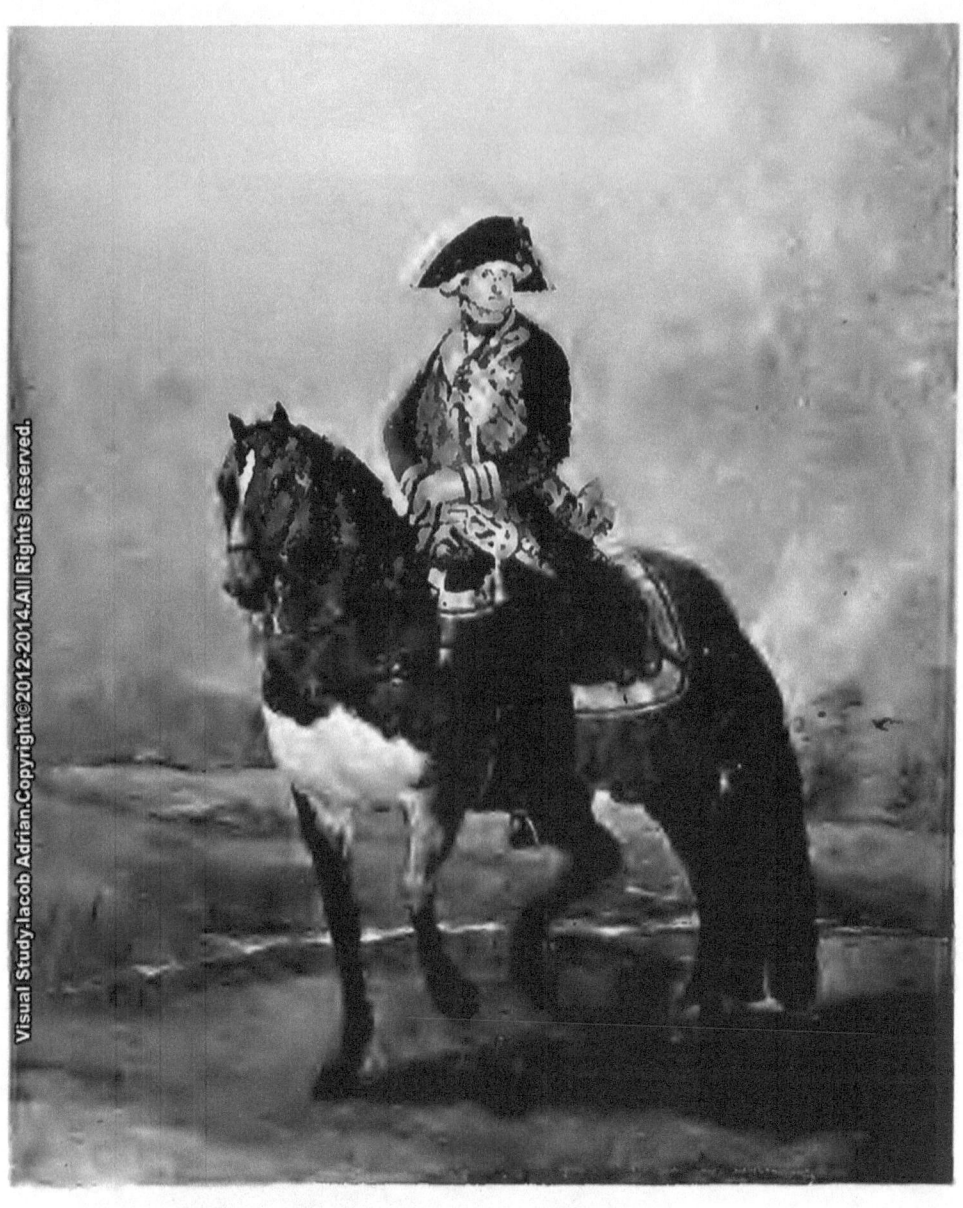

KING CHARLES IV.
(Prado, Madrid)

LE ROI CHARLES IV.
(Prado, Madrid)

KÖNIG KARL IV.
(Madrid, Prado)
F. Hanfstaengl, Photo.

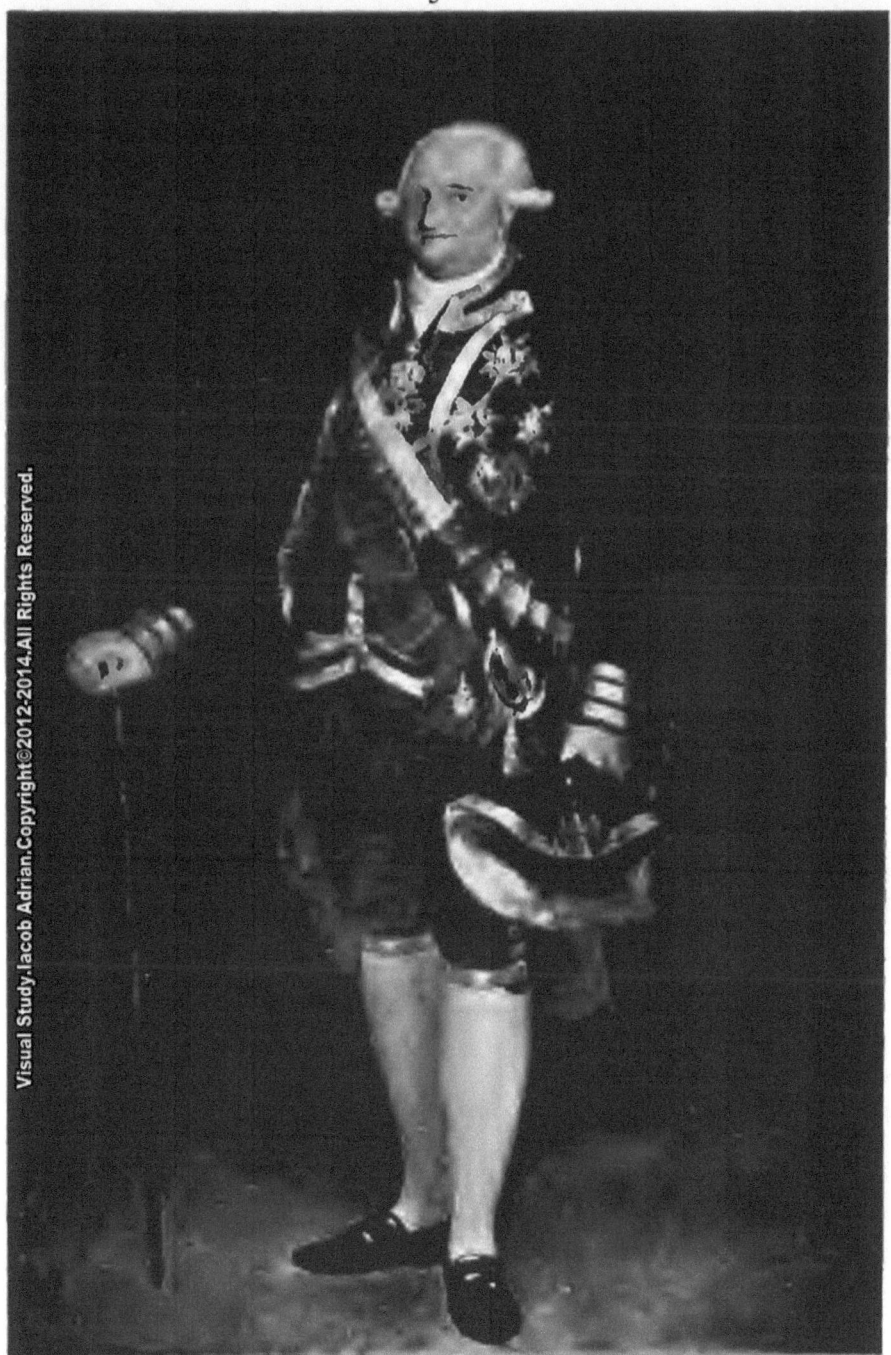

KING CHARLES IV.
(Prado, Madrid)

KÖNIG KARL IV.
(Madrid, Prado)
F. Hanfstaengl, Photo.

LE ROI CHARLES IV.
(Prado, Madrid)

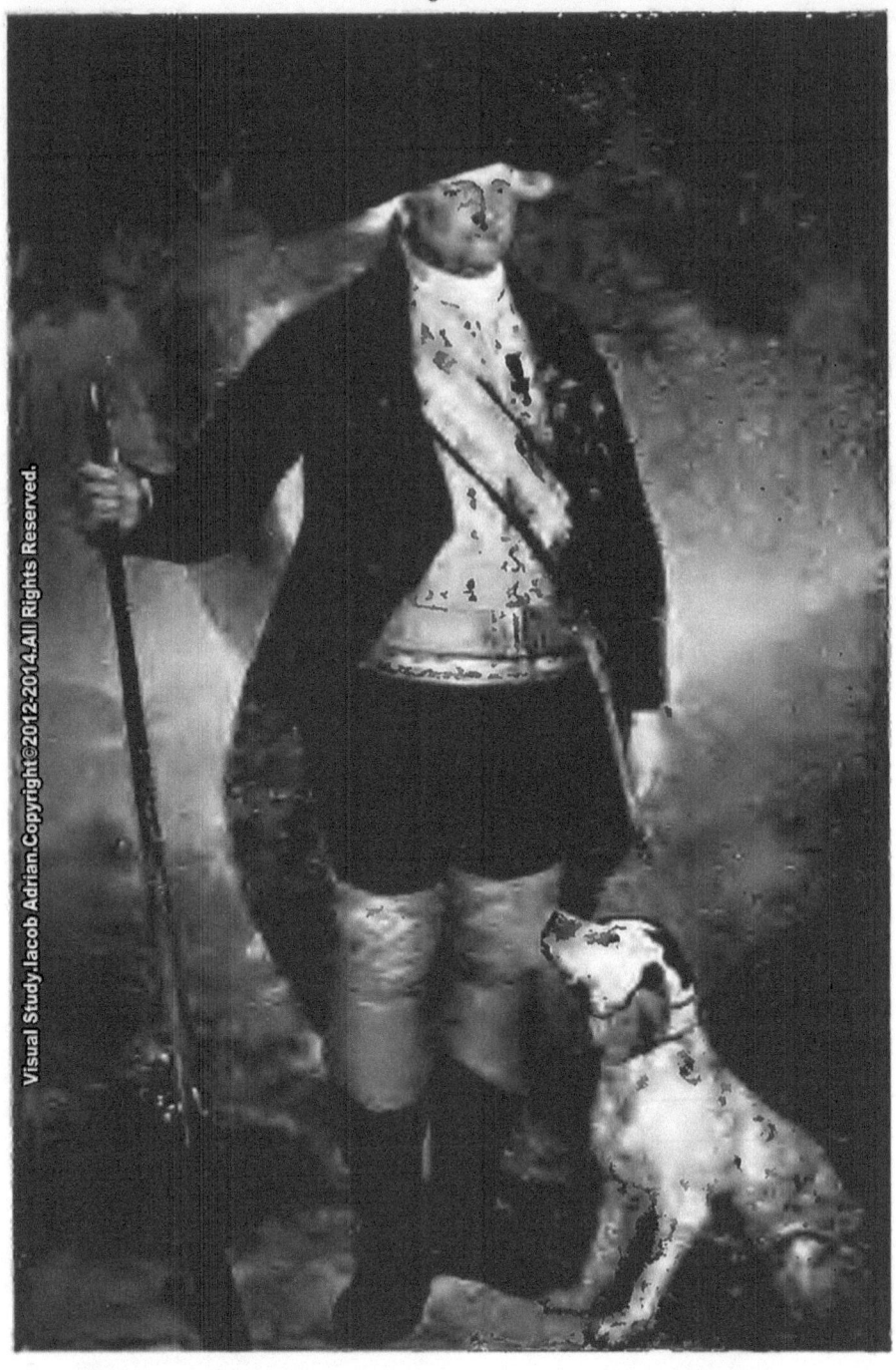

KING CHARLES IV.
(Capodimonte, Naples)

LE ROI CHARLES IV.
(Capodimonte, Naples)

KÖNIG KARL IV.
(Neapel, Capodimonte)

Frat. Alinari, Photo.

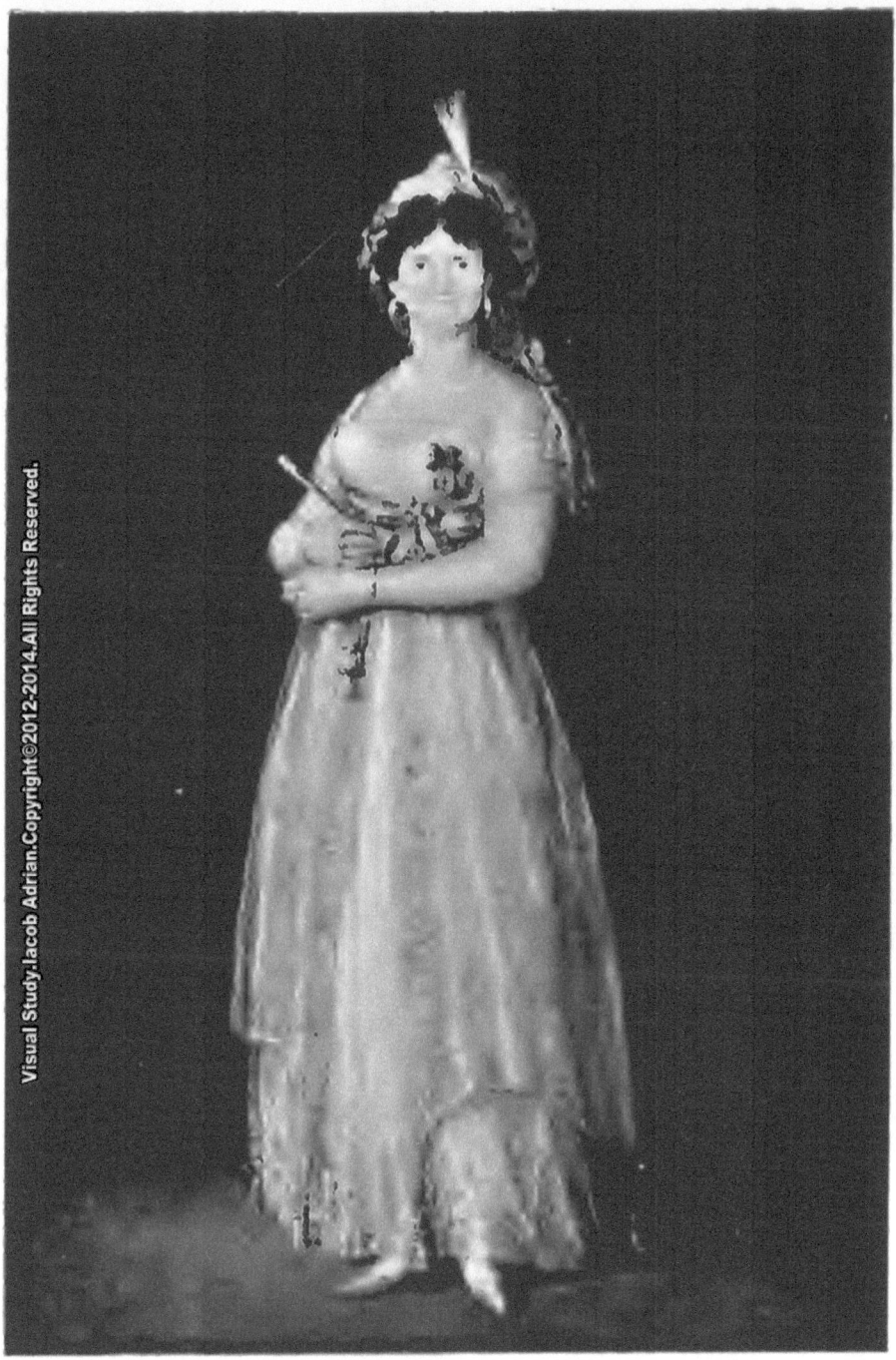

QUEEN MARY LOUISA
(Capodimonte, Naples)

LA REINE MARIE-LOUISE
(Capodimonte, Naples)

KÖNIGIN MARIA LUISE
(Neapel, Capodimonte)

Frat. Alinari, Photo.

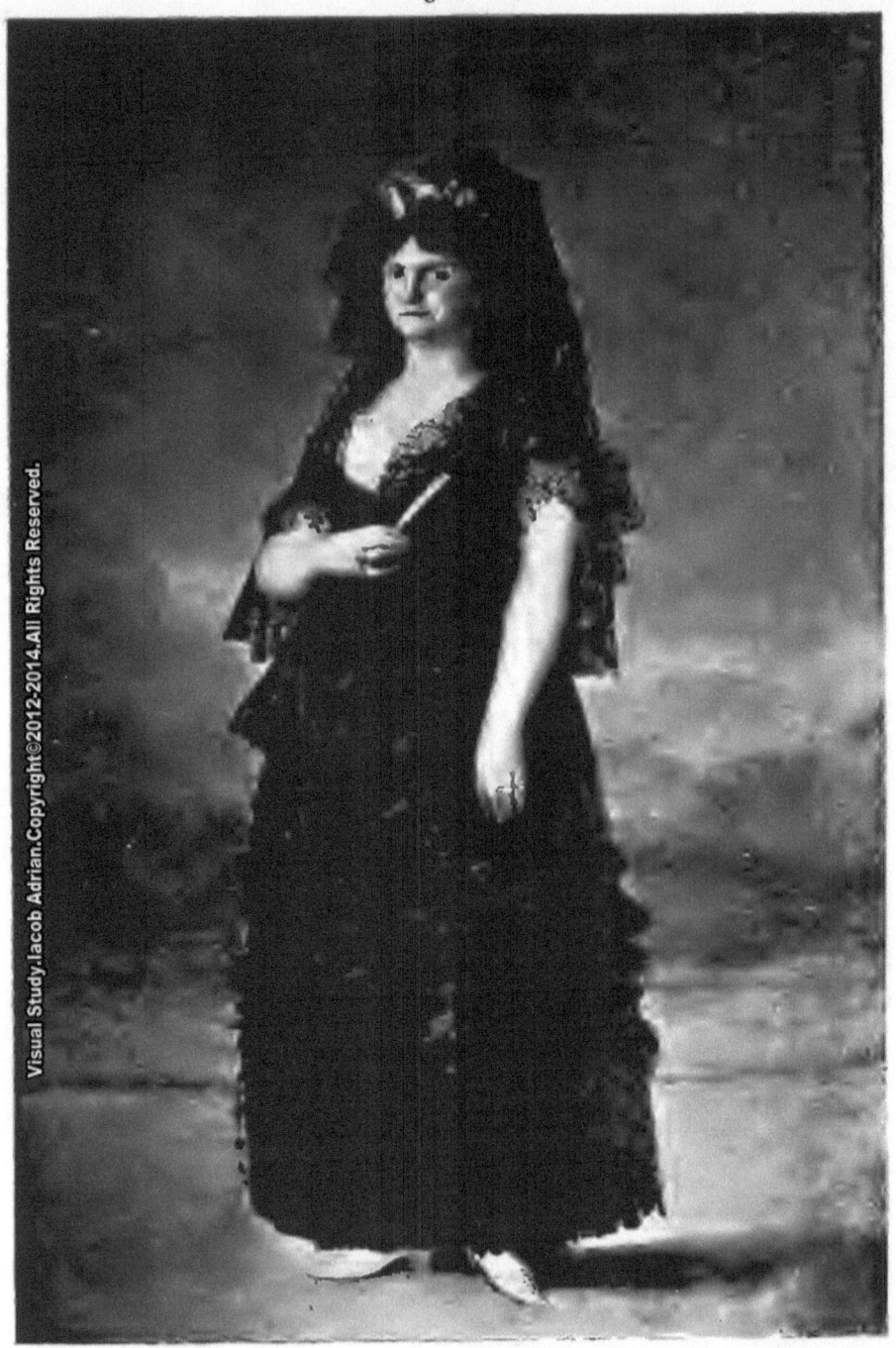

QUEEN MARY LOUISA LA REINE MARIE-LOUISE
(Prado, Madrid) (Prado, Madrid)
KÖNIGIN MARIA LUISE
(Madrid, Prado)
F. Hanfstaengl, Photo.

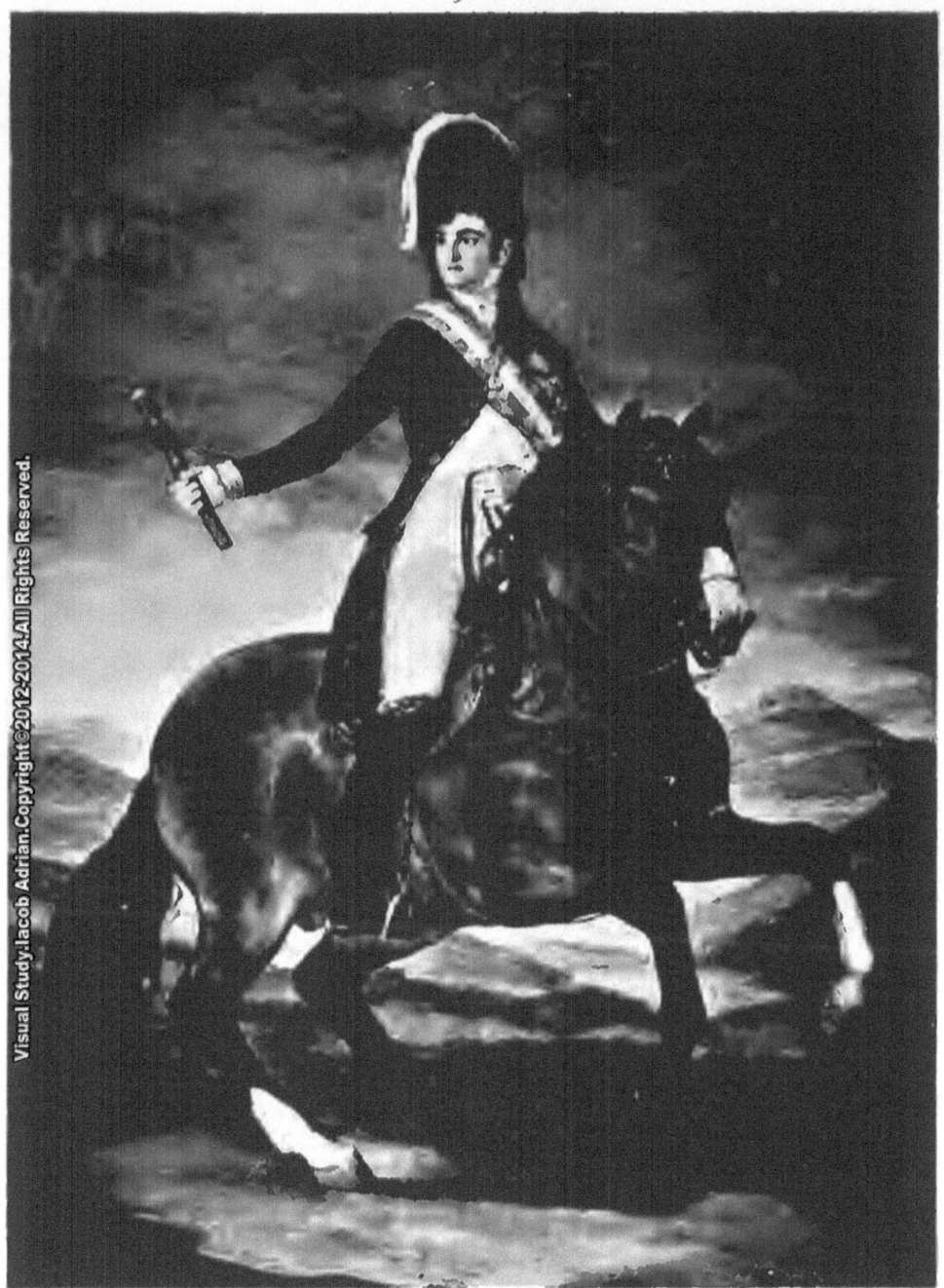

KING FERDINAND VII.
(Academy of St. Ferdinand, Madrid)

LE ROI FERDINAND VII.
(Académie de St-Ferdinand, Madrid)

KÖNIG FERDINAND VII.
(Madrid, Akademie des St. Ferdinand)

D. Anderson, Photo.

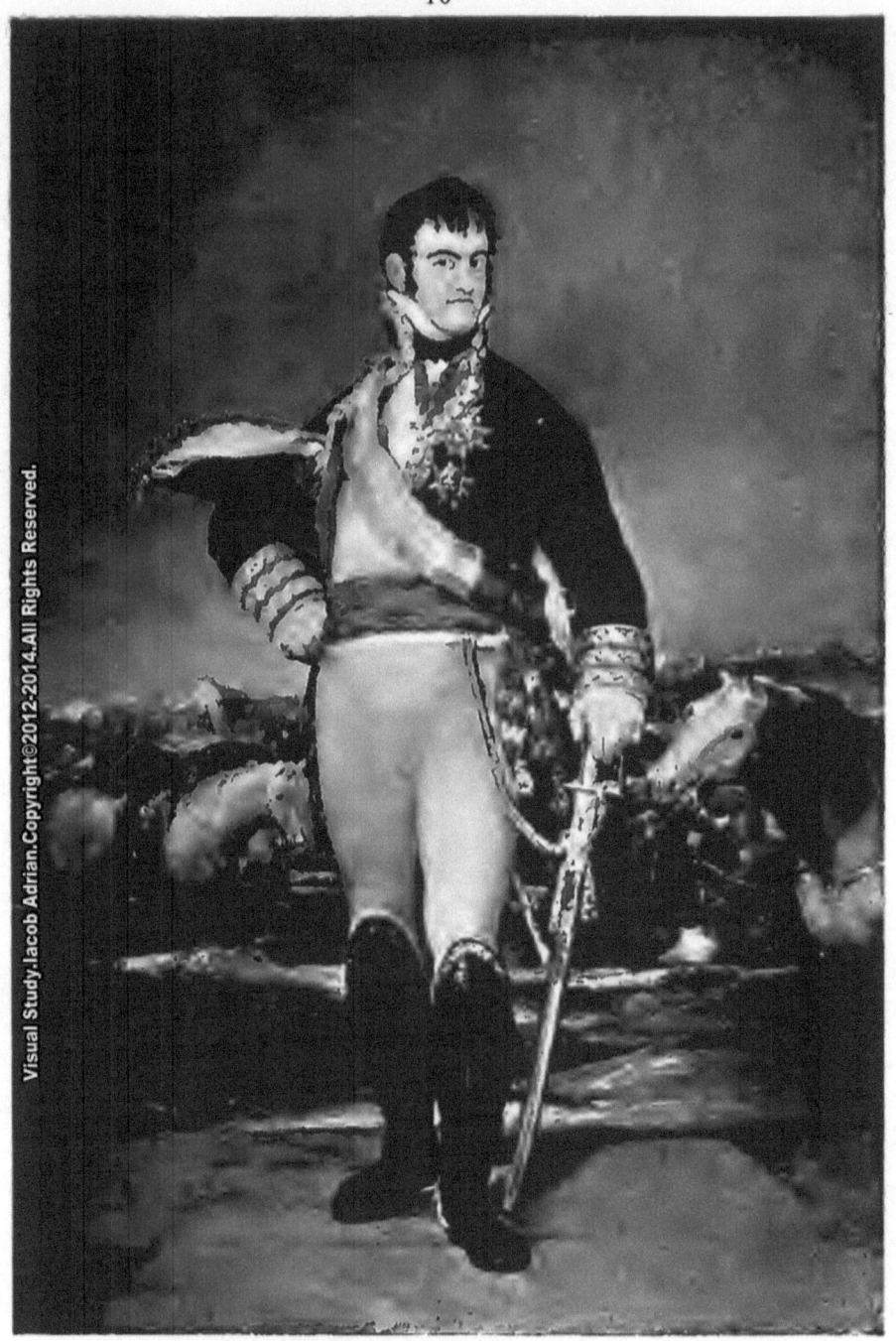

King Ferdinand VII.
(*Prado, Madrid*)

Le Roi Ferdinand VII.
(*Prado, Madrid*)

König Ferdinand VII.
(*Madrid, Prado*)

D. Anderson, Photo.

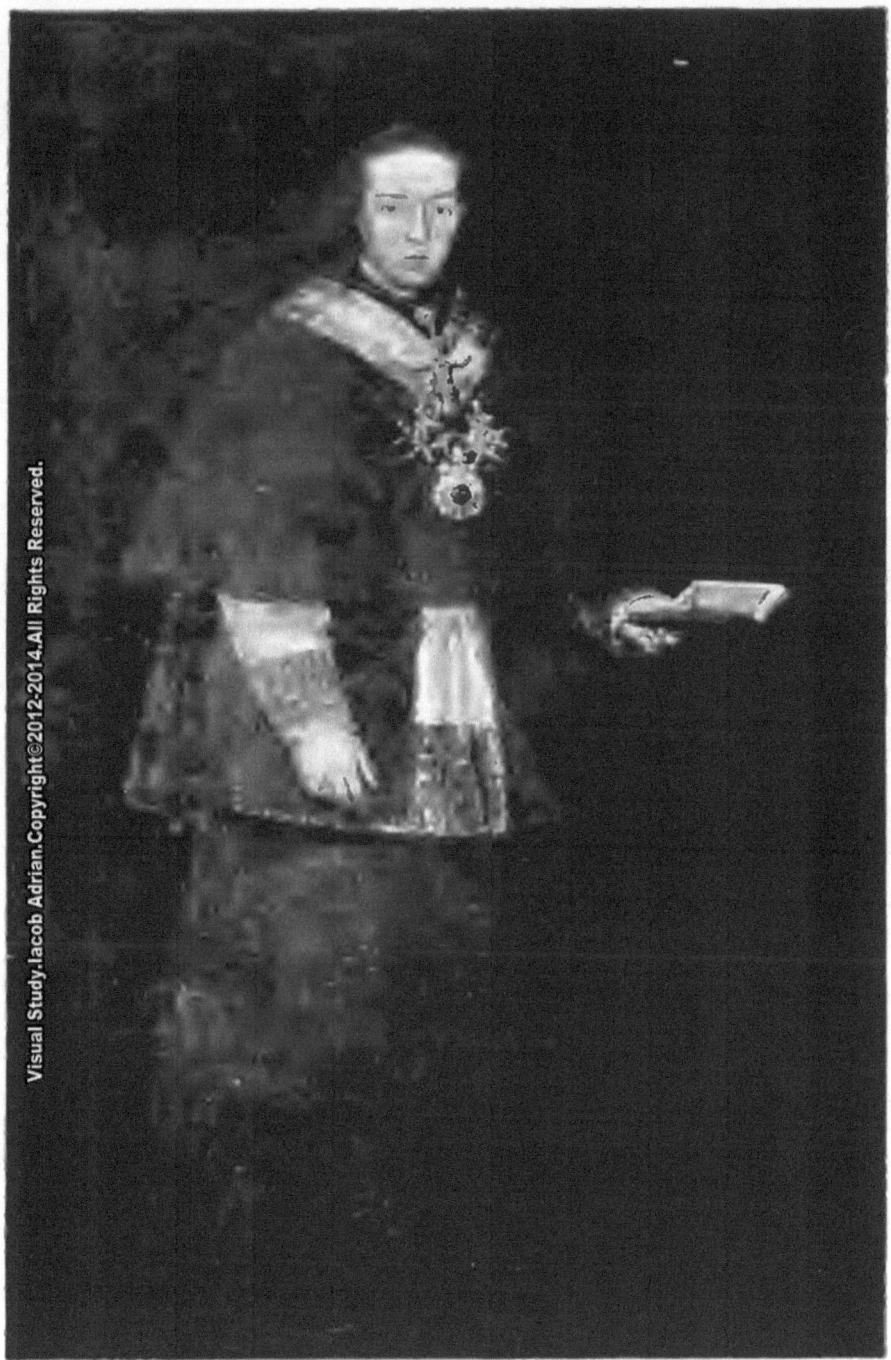

CARDINAL LOUIS OF BOURBON — LE CARDINAL LOUIS DE BOURBON
KARDINAL LUDWIG VON BOURBONE
(*El Marqués de Casa Torres*)
M. Moreno, Photo.

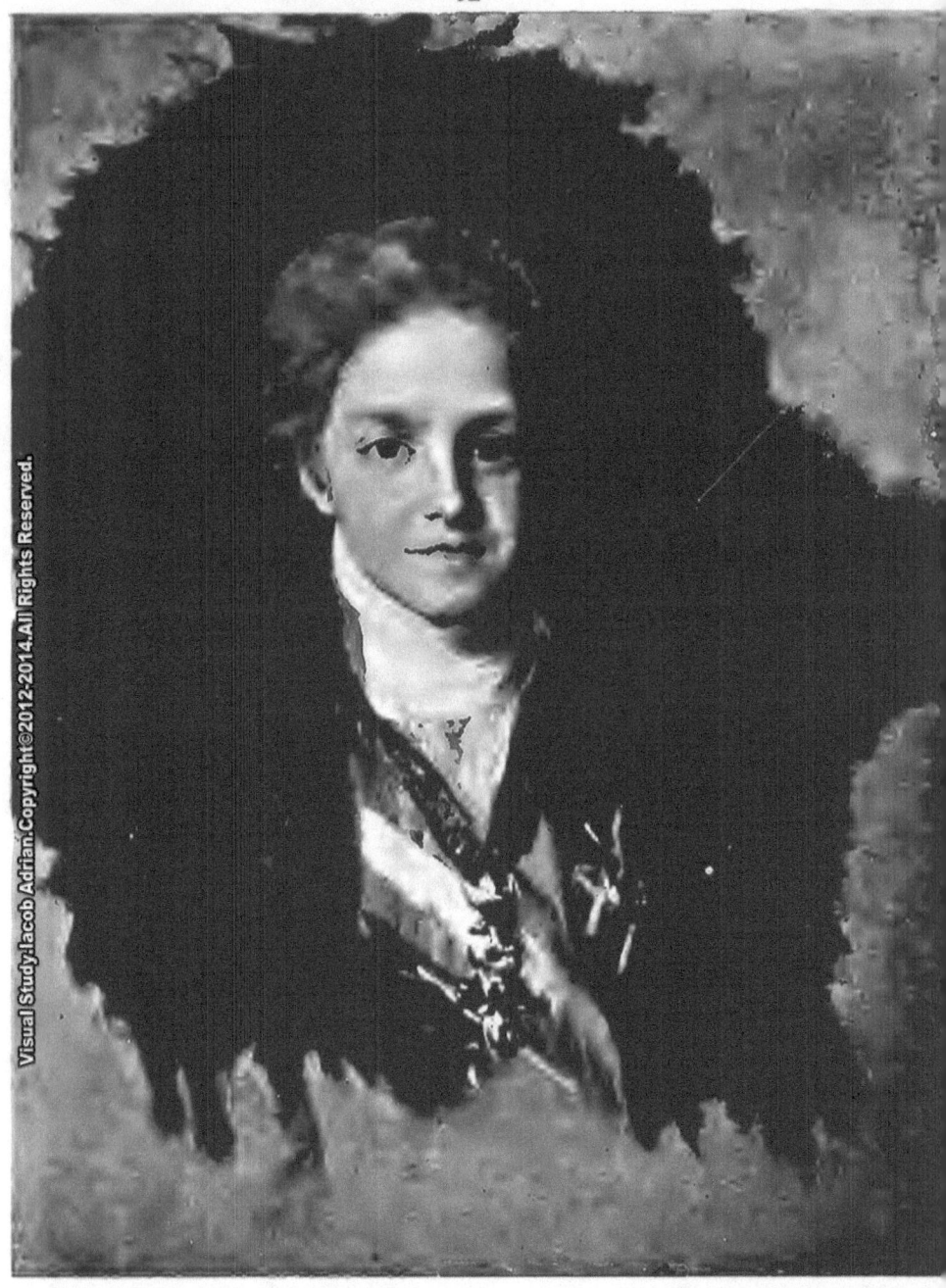

THE INFANTE CHARLES MARY　　　L'INFANT CHARLES-MARIE
(*Prado, Madrid*)　　　　　　　　(*Prado, Madrid*)
DER INFANT KARL MARIA
(*Madrid, Prado*)
D. Anderson, Photo.

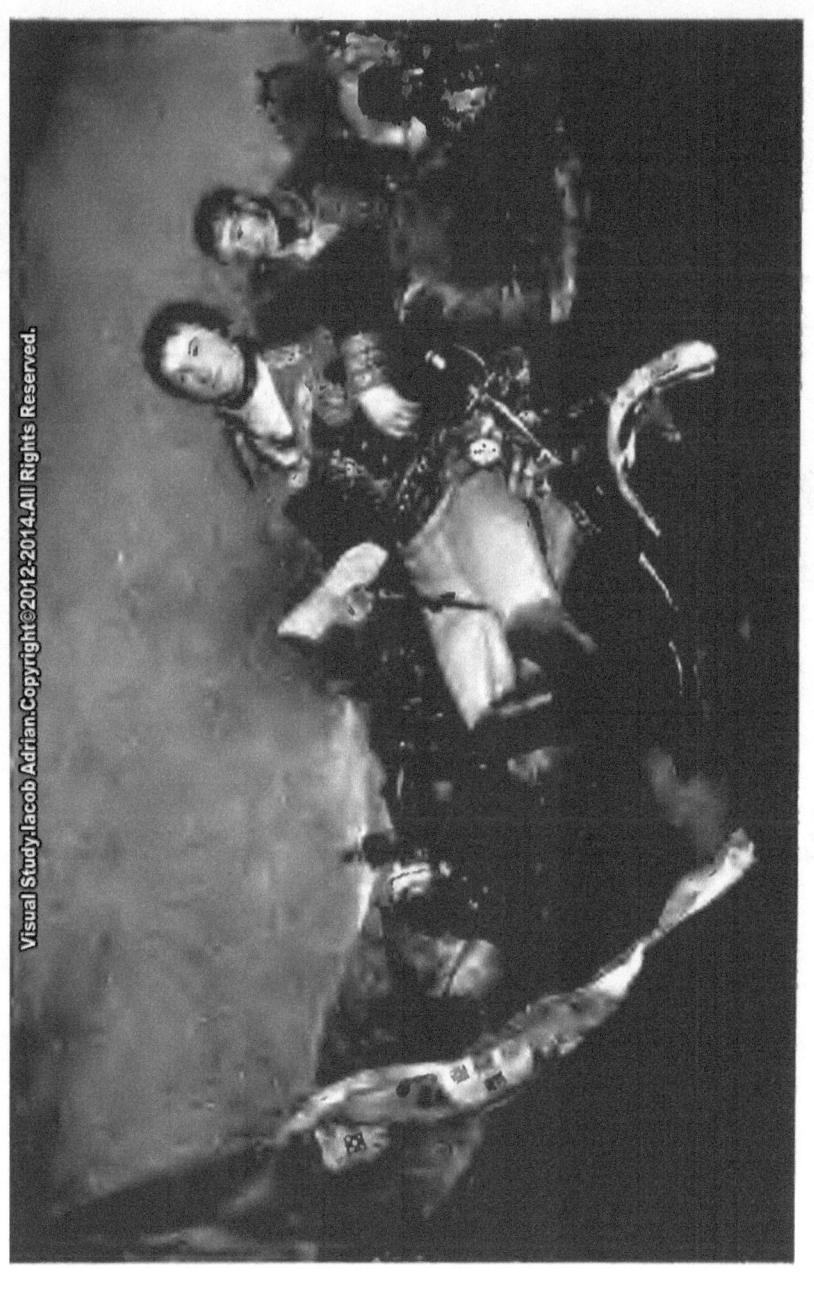

Don Manuel Godoy, Principe de la Paz
(Academy of St. Ferdinand, Madrid)

Don Manuel Godoy, Principe de la Paz
(Académie de St-Ferdinand, Madrid)

Don Manuel Godoy, Principe de la Paz
(Madrid, Akademie des St. Ferdinand)

D. Anderson, Photo.

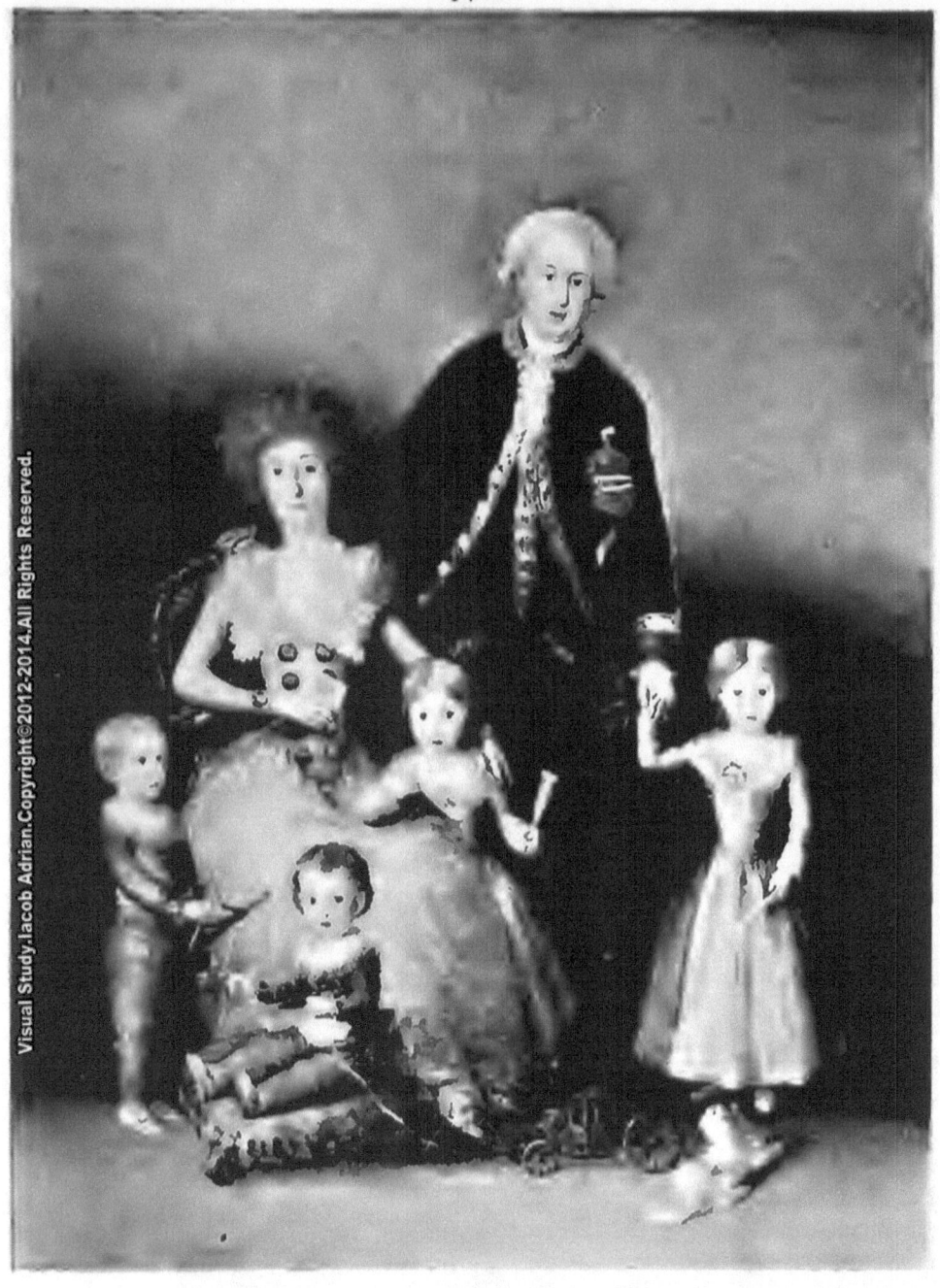

THE DUKE OF OSUNA AND HIS FAMILY
(*Prado, Madrid*)

LE DUC D'OSSUNA ET SA FAMILLE
(*Prado, Madrid*)

DER HERZOG VON OSUNA UND SEINE FAMILIE
(*Madrid, Prado*) *D. Anderson, Photo.*

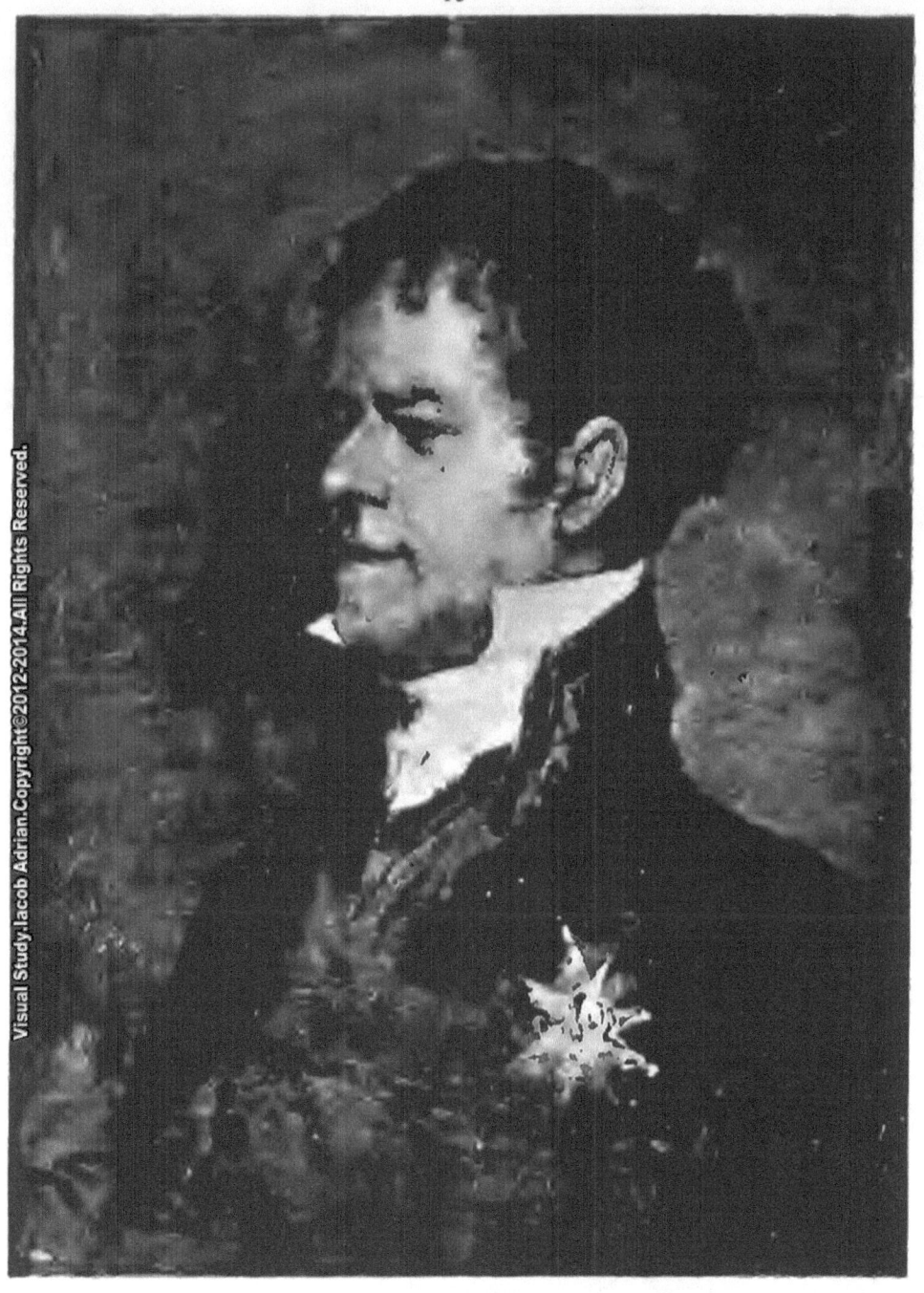

THE DUKE OF SAN CARLOS LE DUC DE SAN CARLOS
DER HERZOG VON SAN CARLOS
(*El Conde de Villagonzalo*)
M. Moreno, Photo.

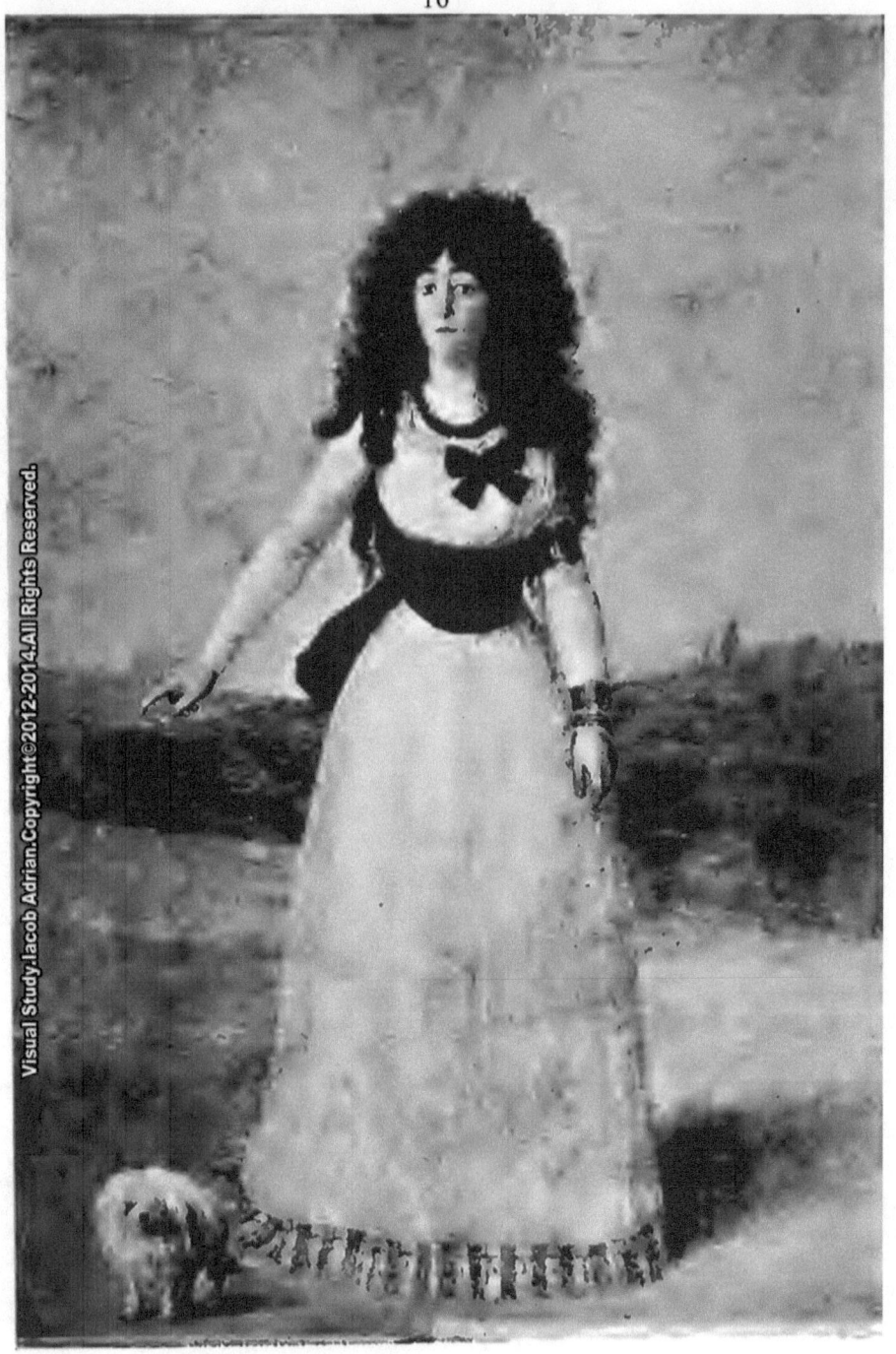

THE DUCHESS OF ALBA　　　LA DUCHESSE D'ALBE
(*The Duke of Alba*)　　　(*Le Duc d'Albe*)
DIE HERZOGIN VON ALBA
(*Der Herzog von Alba*)
M. Moreno, Photo.

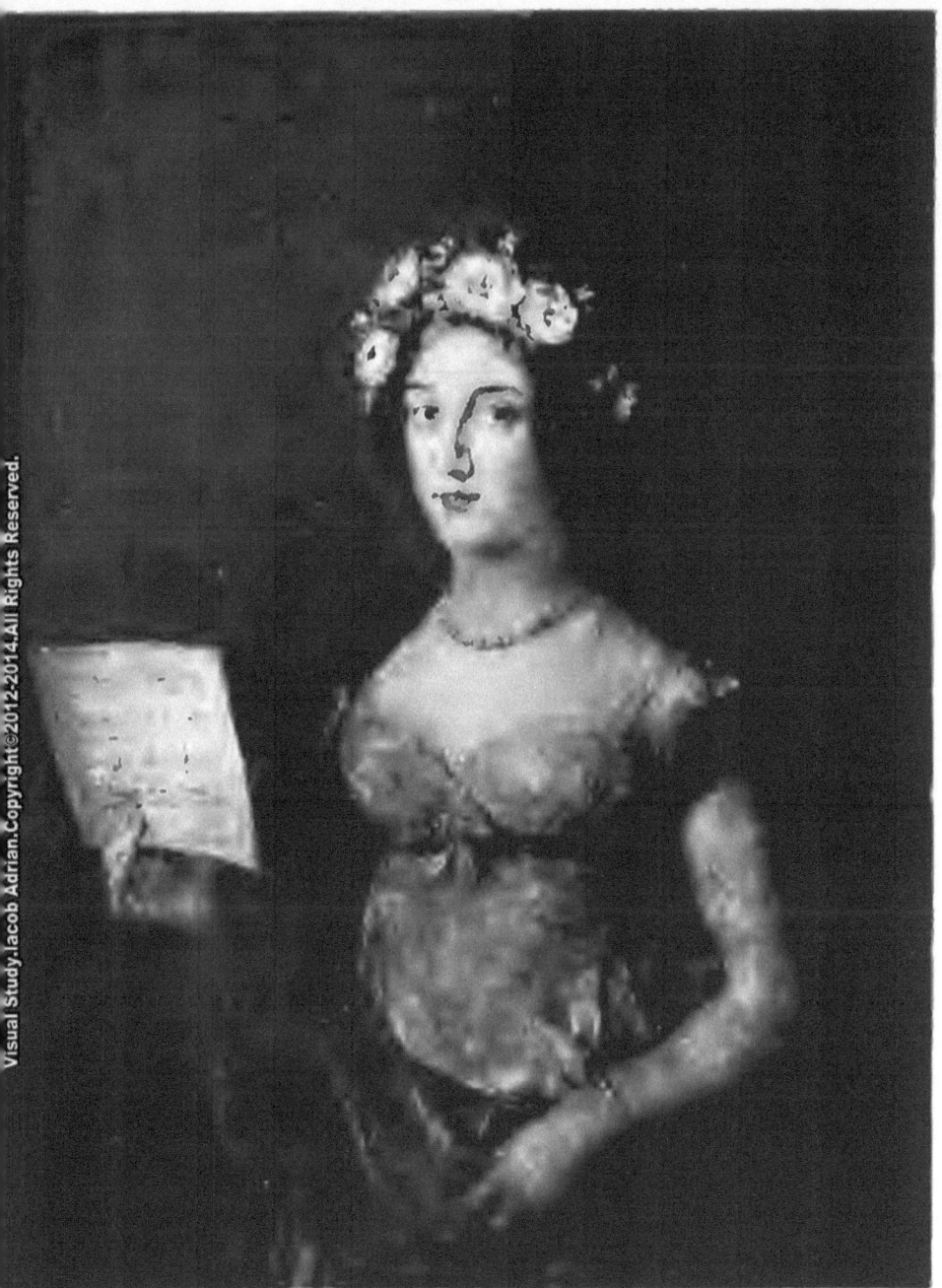

The Duchess of Abrantes
(*The Duchess of Abrantes*)

La Duchesse d'Abrantès
(*La Duchesse d'Abrantès*)

Die Herzogin von Abrantes
(*Die Herzogin von Abrantes*)

M. Moreno, Photo.

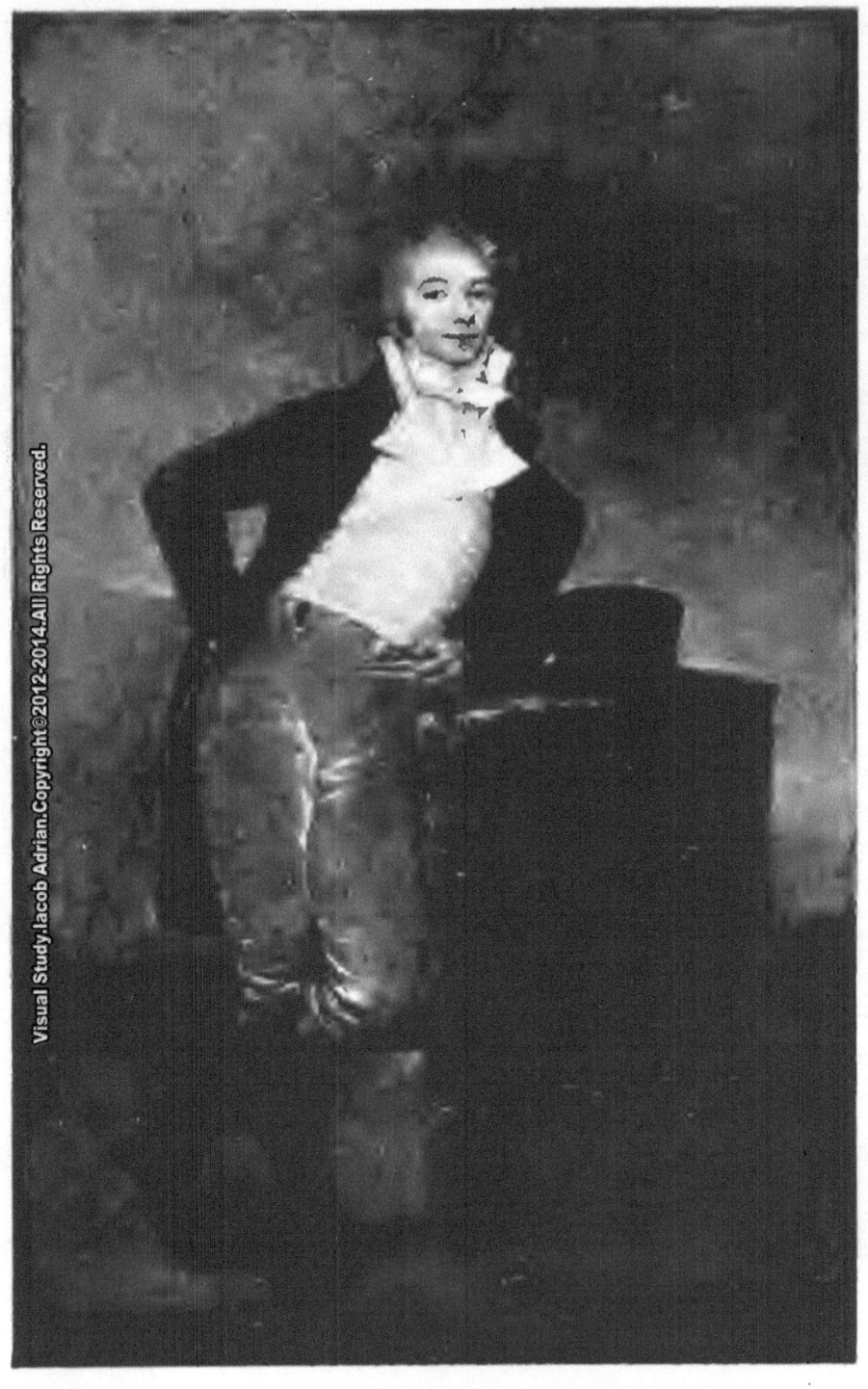

EL MARQUÉS DE SAN ADRIAN
(*El Marqués de San Adrian*)
M. Moreno, Photo.

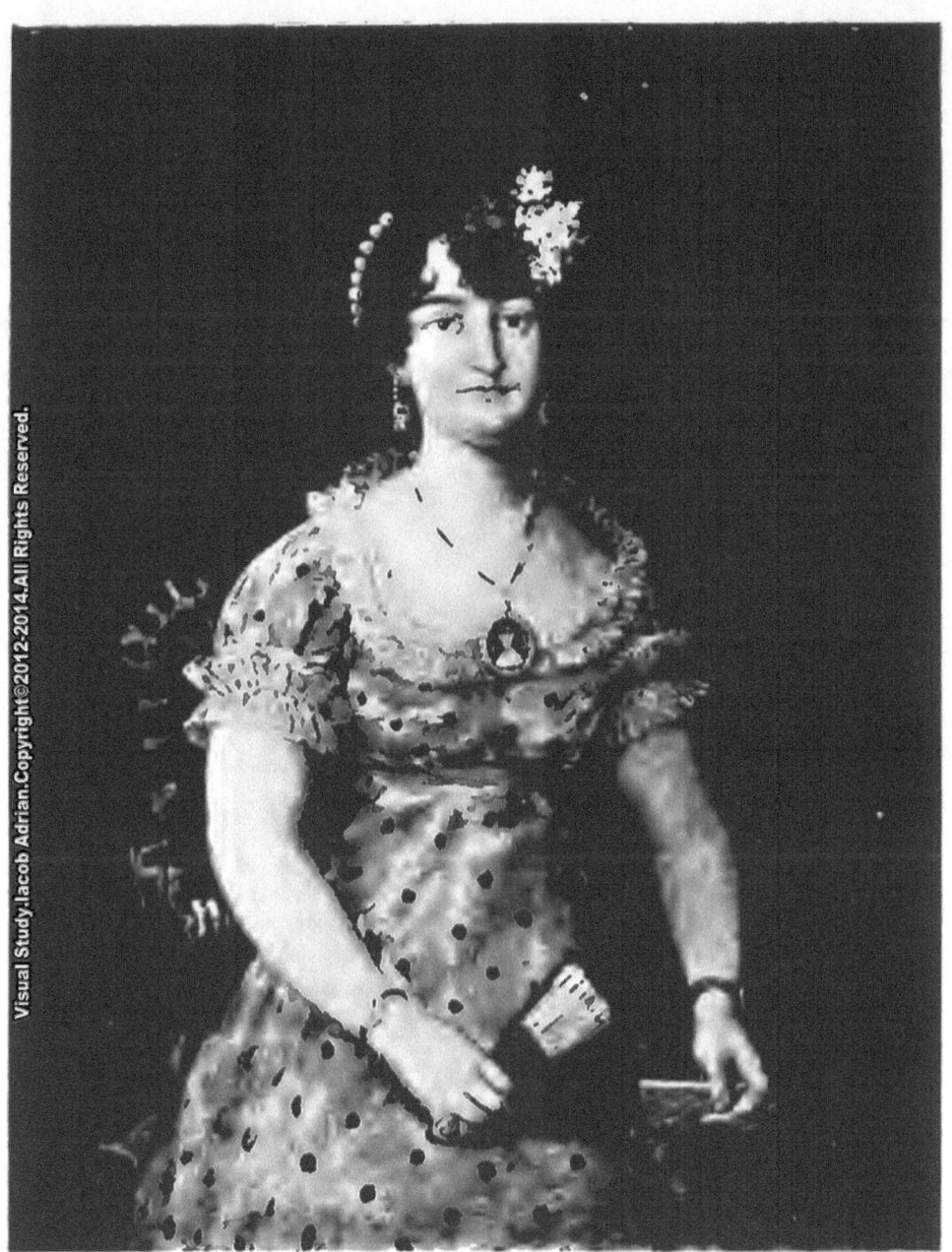

La Marquesa de Caballero
(*El Marqués de Corvera*)
M. Moreno, Photo.

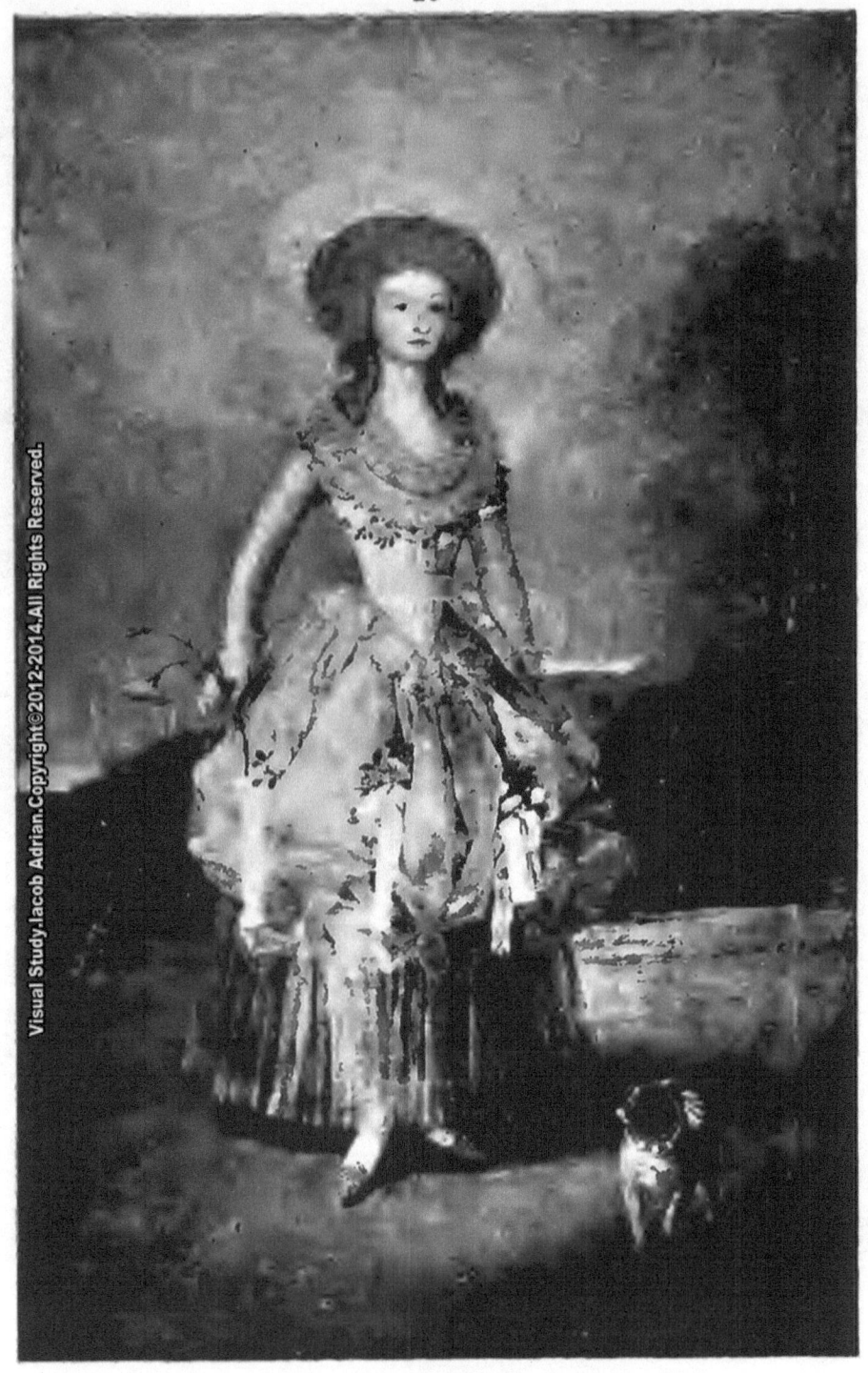

LA MARQUESA DE PONTEJOS
(*La Marquesa de Martorell*)
M. Moreno, Photo.

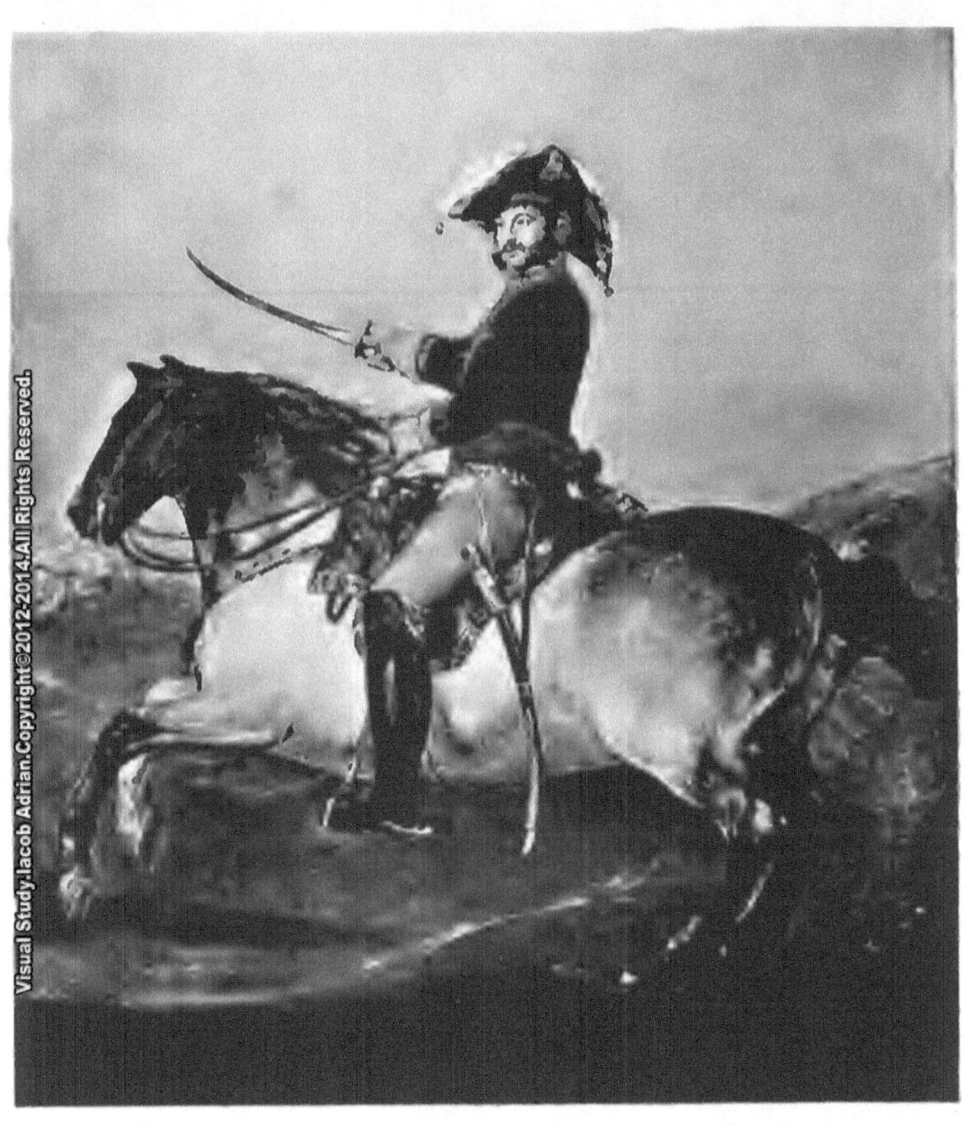

GENERAL PALAFOX
(*Prado, Madrid*)

LE GÉNÉRAL PALAFOX
(*Prado, Madrid*)

DER GENERAL PALAFOX
(*Madrid, Prado*)
F. Hanfstaengl, Photo.

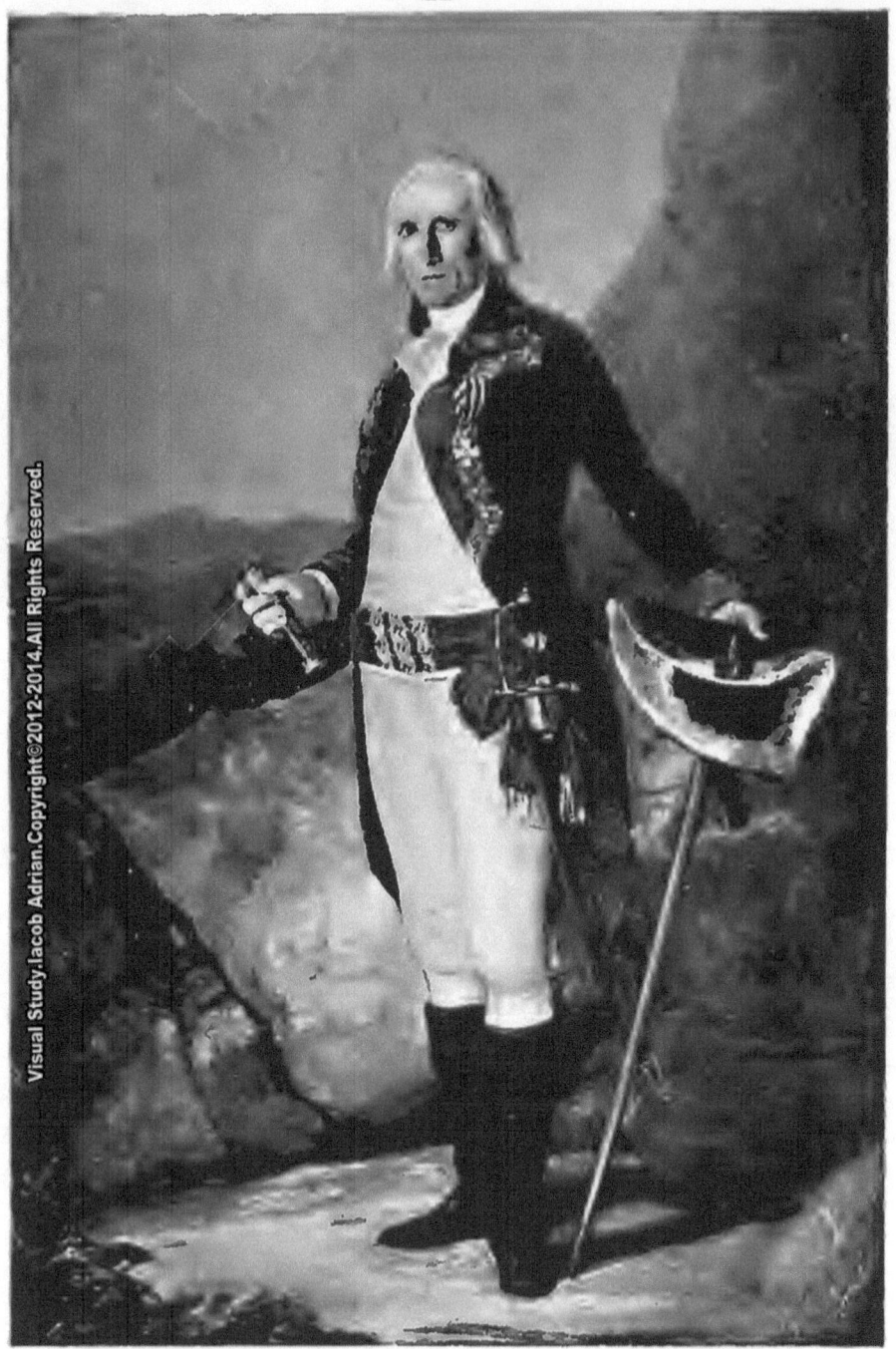

GENERAL URRUTIA
(*Prado, Madrid*)

LE GÉNÉRAL URRUTIA
(*Prado, Madrid*)

DER GENERAL URRUTIA
(*Madrid, Prado*)

F. Hanfstaengl, Photo.

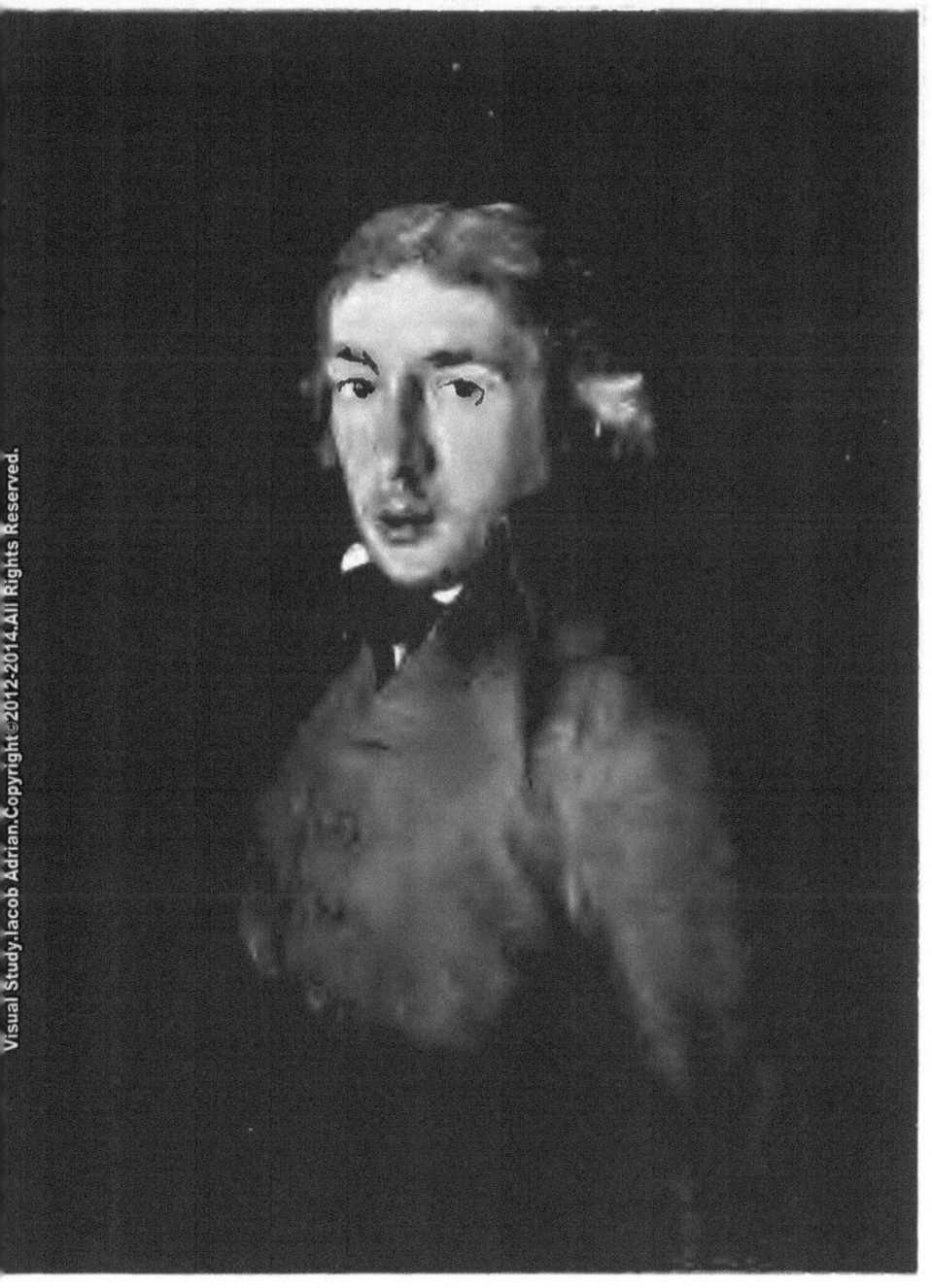

Don Leandro Fernández de Moratín
(Academy of St. Ferdinand, Madrid) (Académie de St-Ferdinand, Madrid)
(Madrid, Akademie des St. Ferdinand)
D. Anderson, Photo.

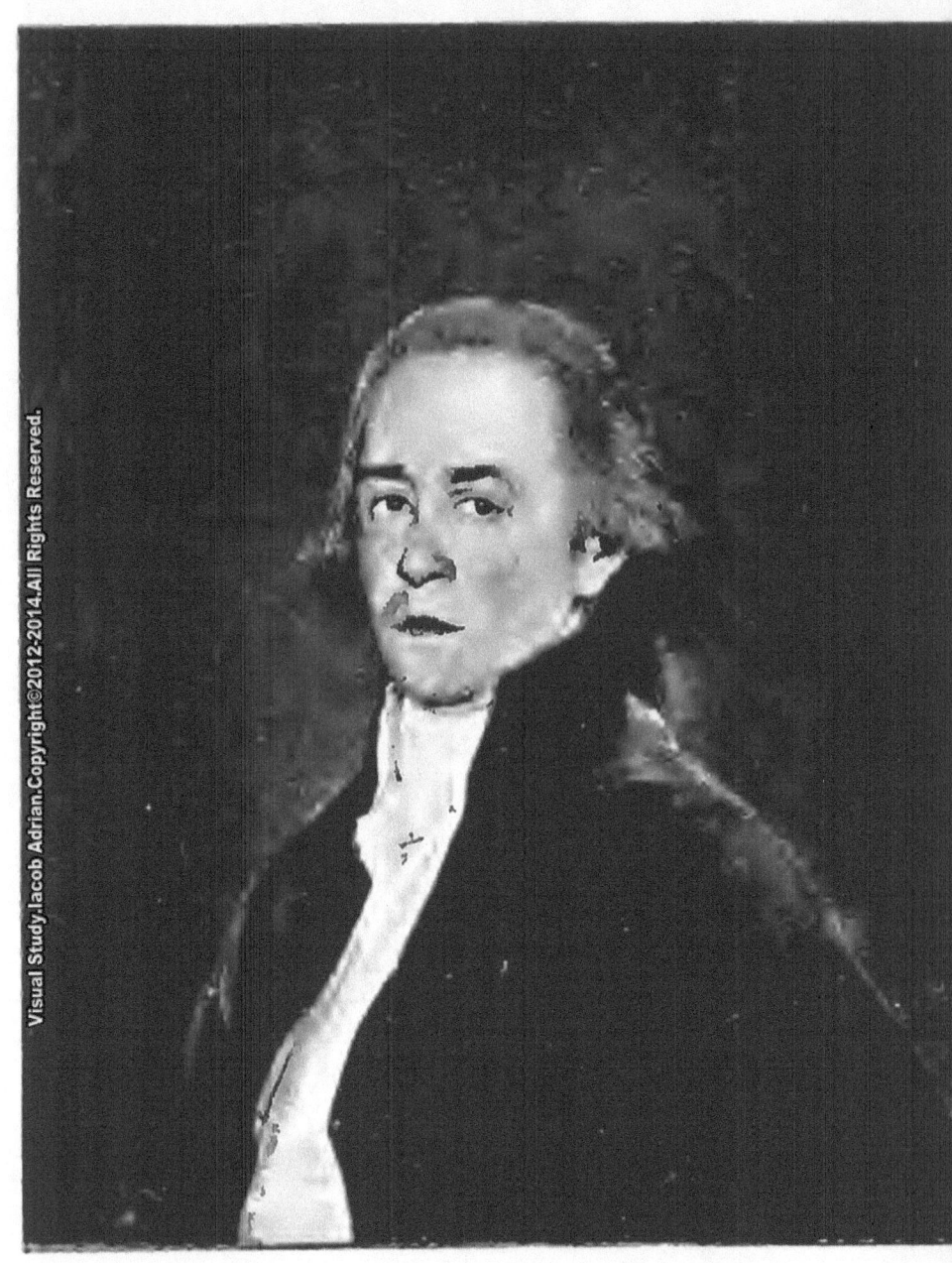

Don Juan Meléndez Valdés
(*Bowes Museum*)
F. Hanfstaengl, Photo.

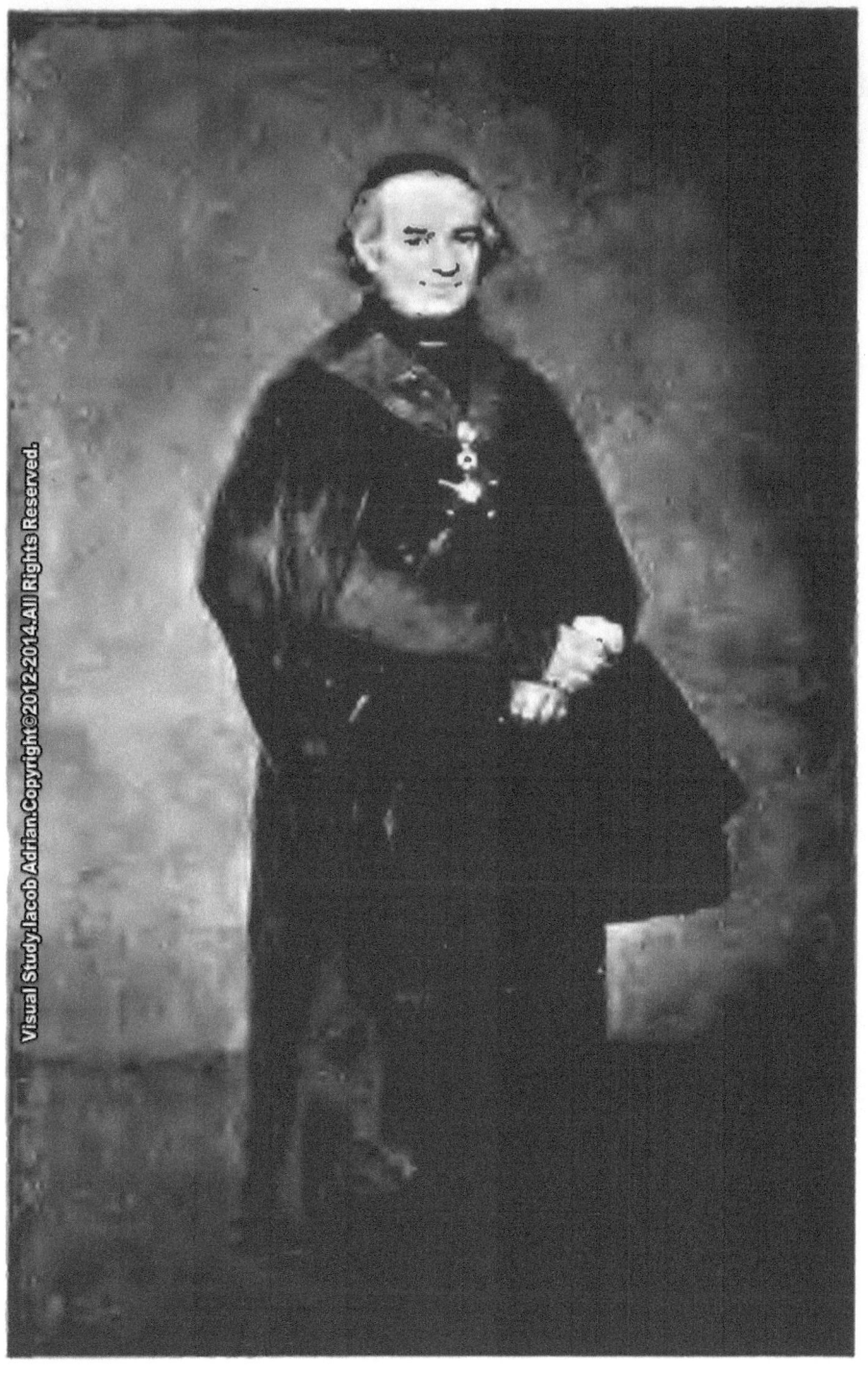

Don Juan Antonio Llorente
(*Don Francisco Llorente*)
M. Moreno, Photo.

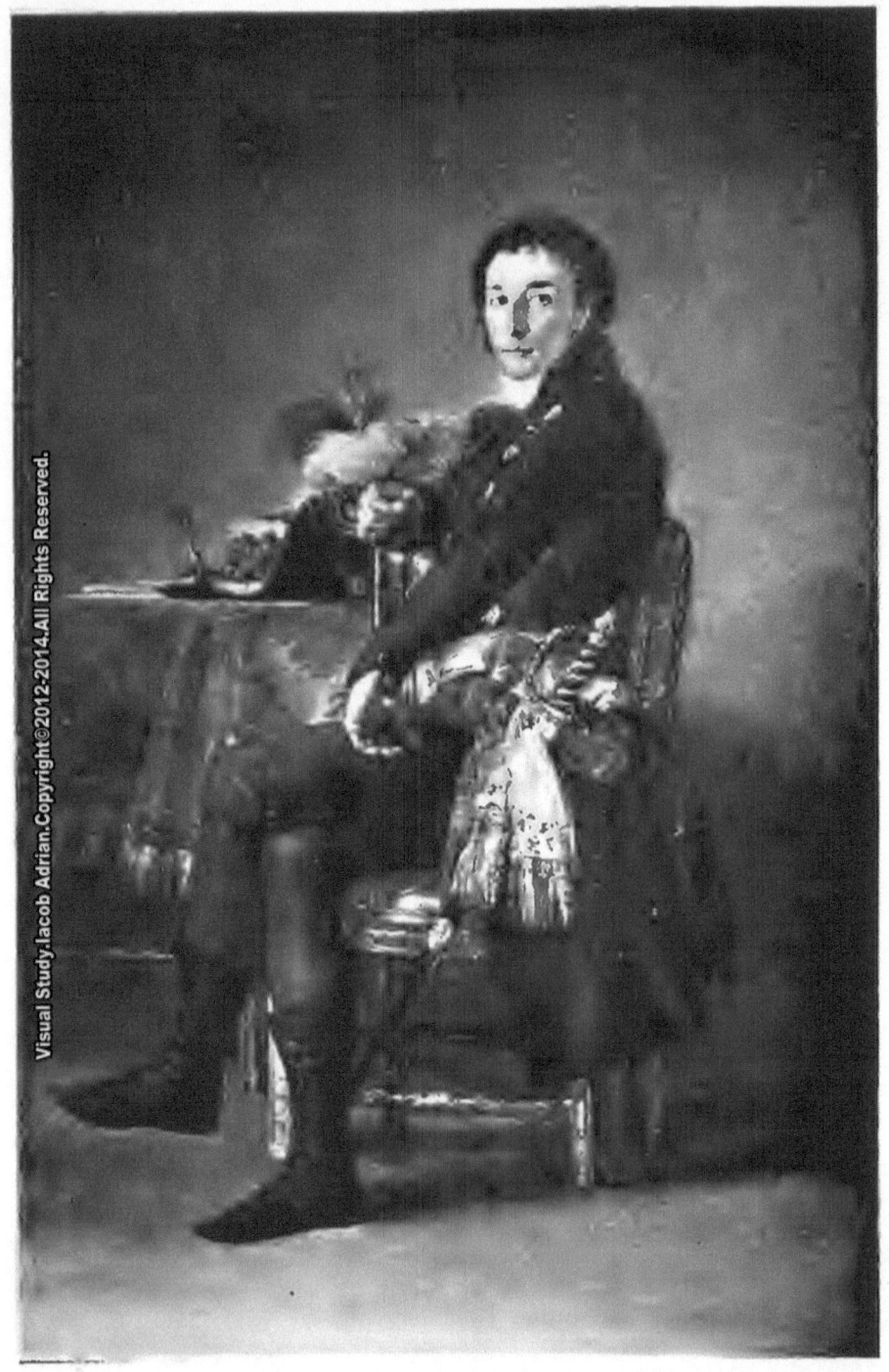

THE AMBASSADOR GUILLEMARDET DER GESANDTE GUILLEMARDET L'AMBASSADEUR GUILLEMARDET
(*Louvre, Paris*) (*Paris, Louvre*) (*Louvre, Paris*)

Braun, Clément & Co., Photo.

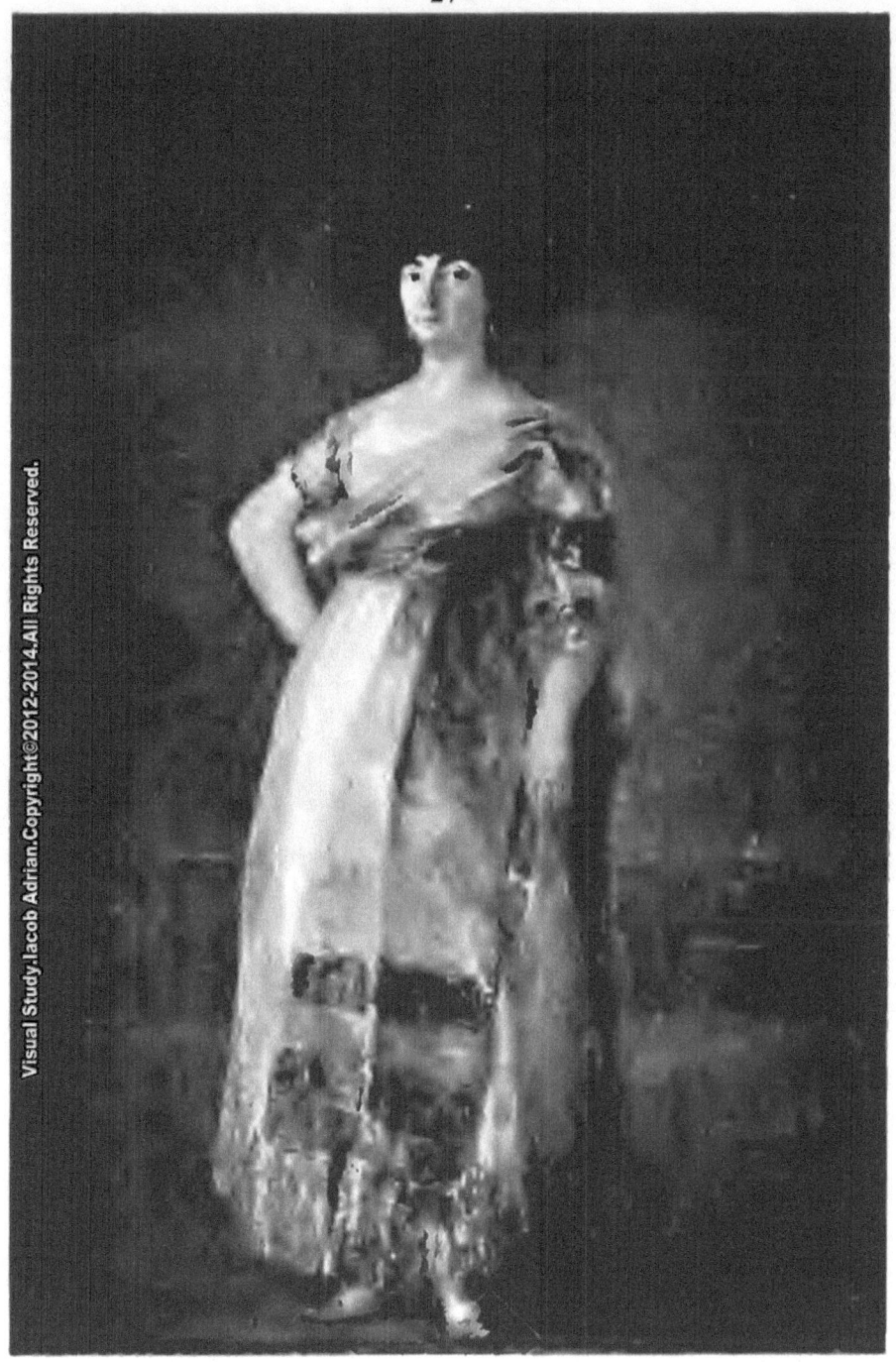

MARIA FERNANDEZ ("LA TIRANA")
(Academy of St. Ferdinand, Madrid) (Académie de St-Ferdinand, Madrid)
(Madrid, Akademie des St. Ferdinana)
D. Anderson, Photo.

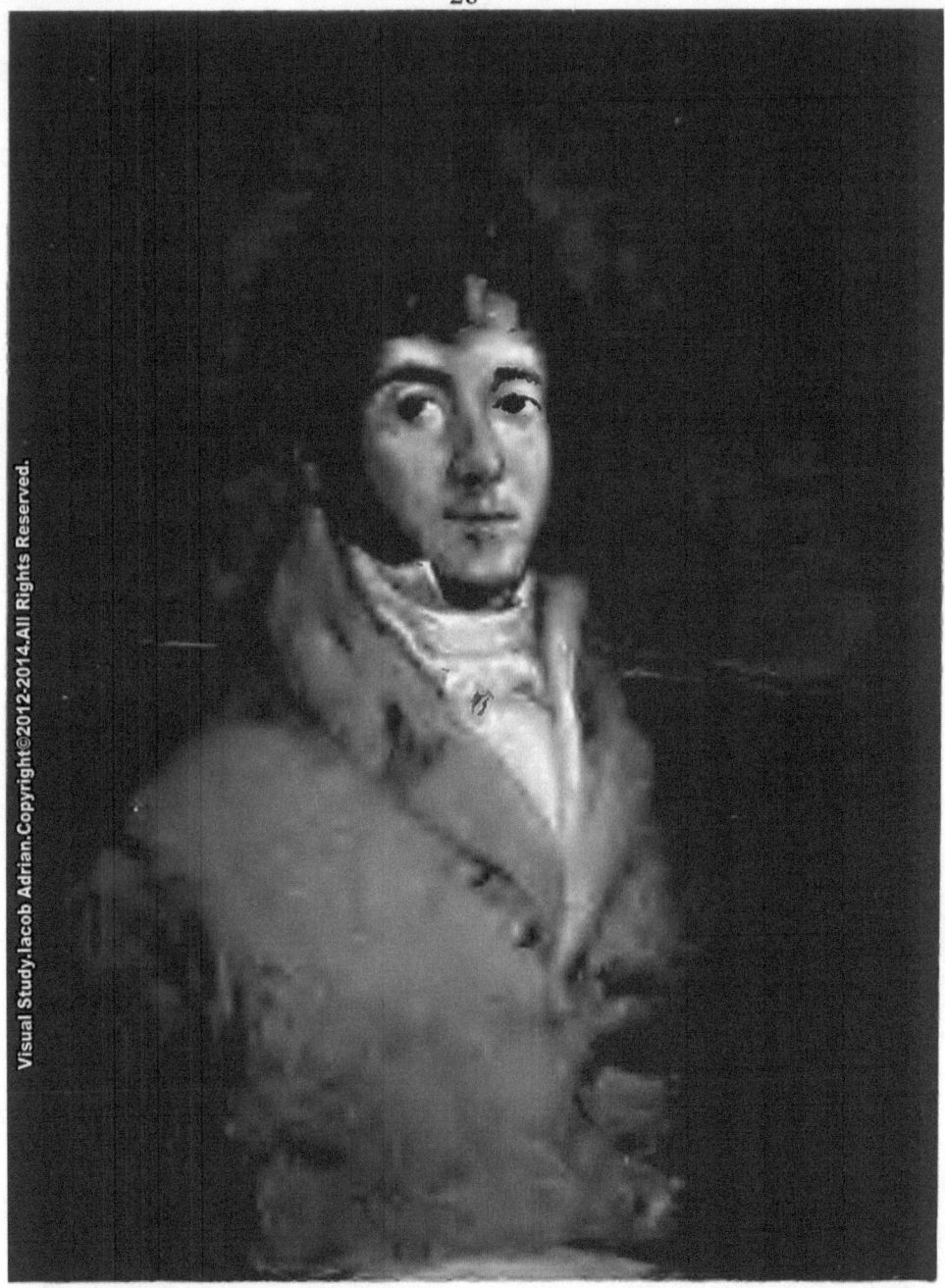

MÁYQUEZ THE ACTOR
(*Prado, Madrid*)

L'ACTEUR MÁYQUEZ
(*Prado, Madrid*)

DER SCHAUSPIELER MÁYQUEZ
(*Madrid, Prado*)

F. Hanfstaengl, Photo.

29

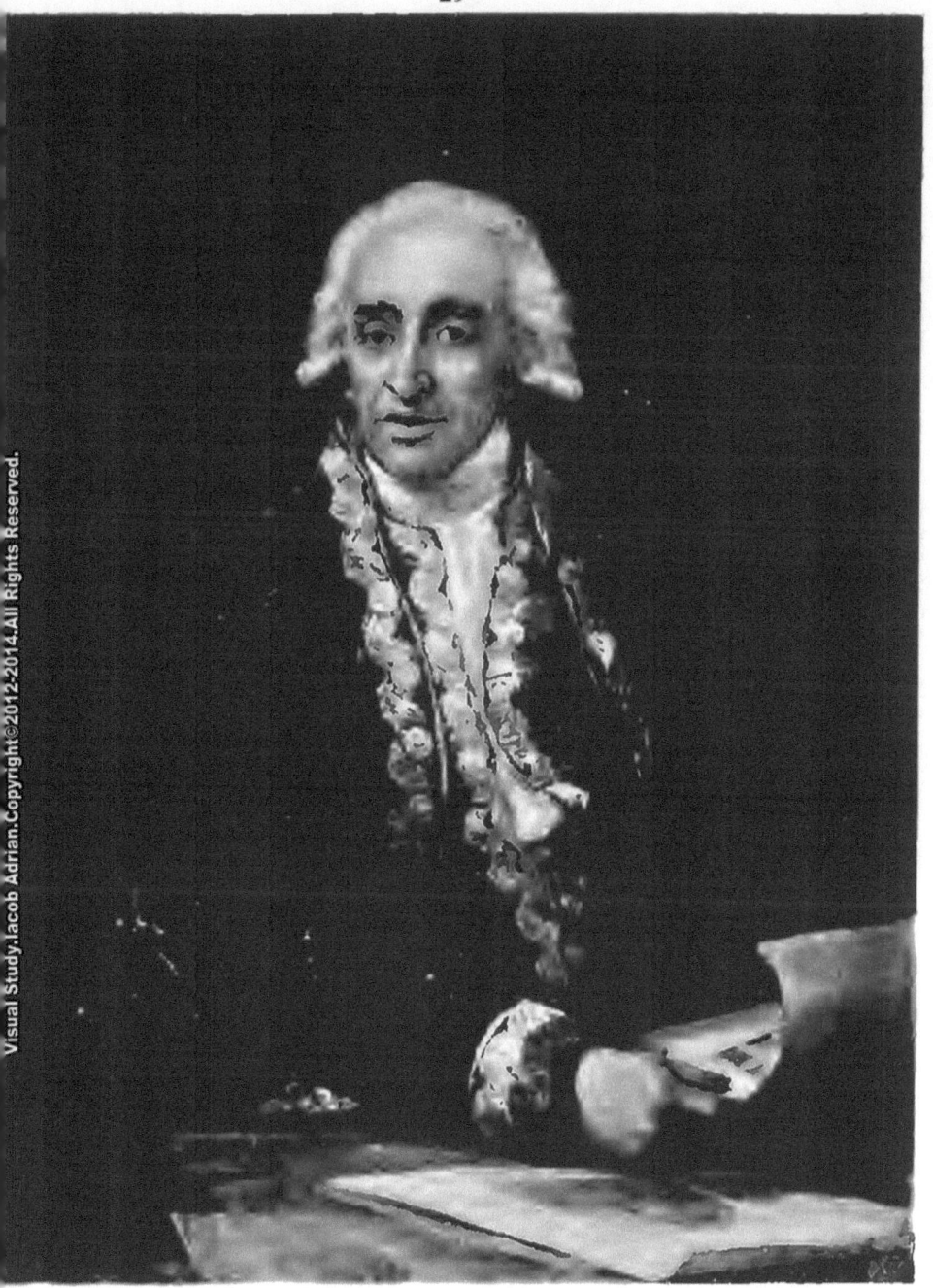

Don Juan de Villanueva
(Academy of St. Ferdinand, Madrid) (Académie de St Ferdinand, Madrid)
(Madrid, Akademie des St. Ferdinand)
D. Anderson, Photo.

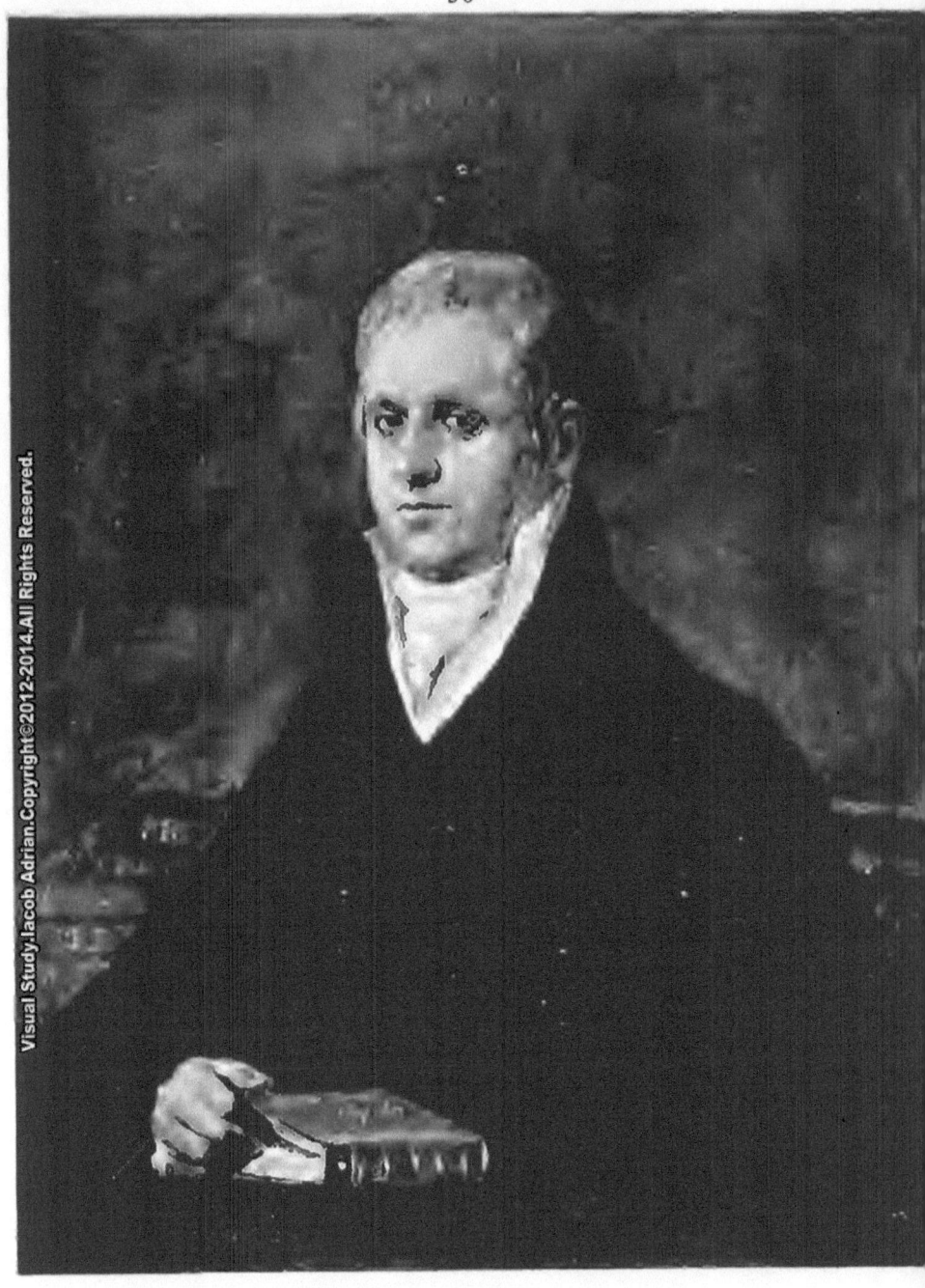

Don José Luis de Muñárriz
(Academy of St. Ferdinand, Madrid) (Académie de St-Ferdinand, Madrid)
(Madrid, Akademie des St. Ferdinand)
D. Anderson, Photo.

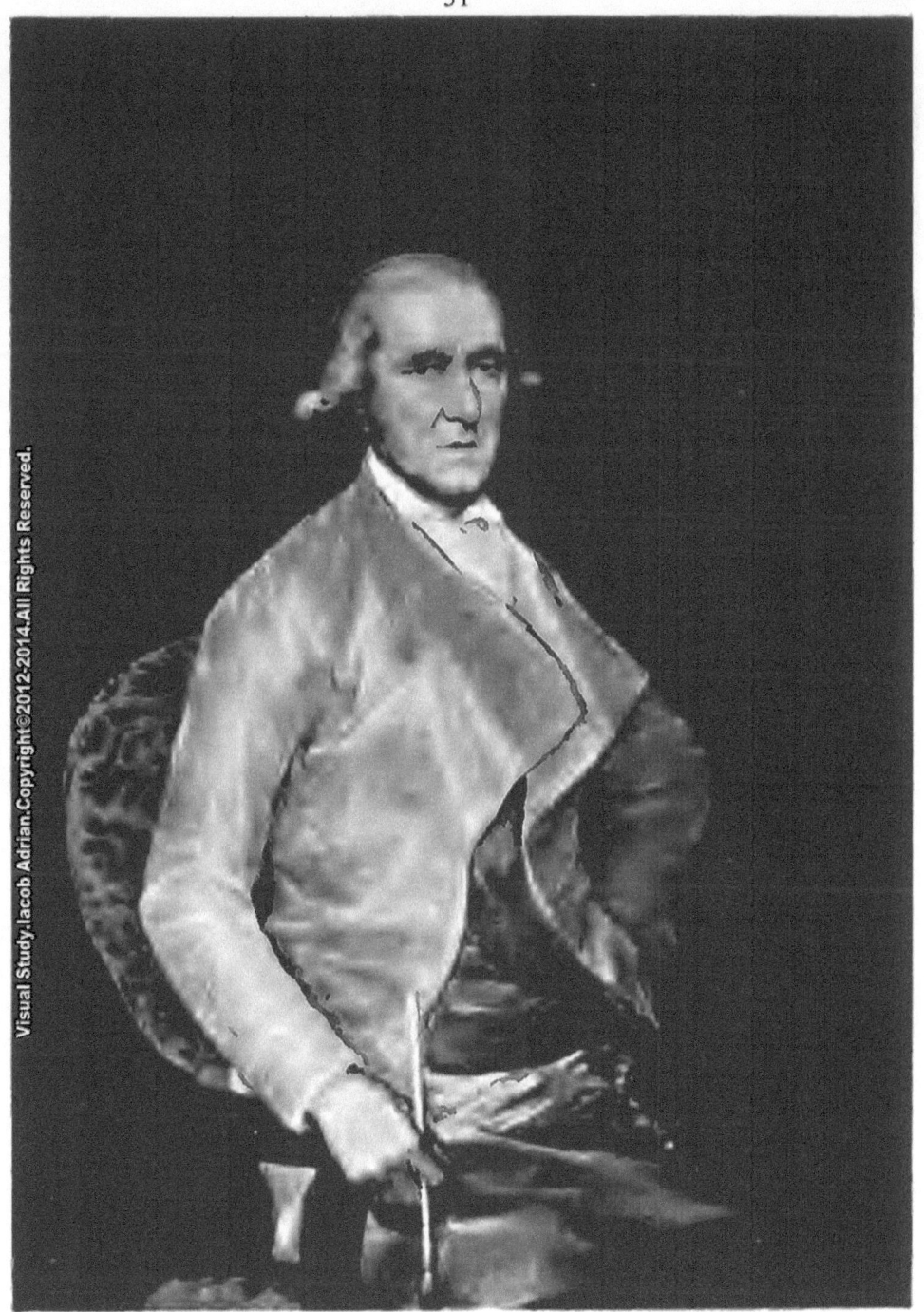

Don Francisco Bayeu
(*Prado, Madrid*)
F. Hanfstaengl, Photo.

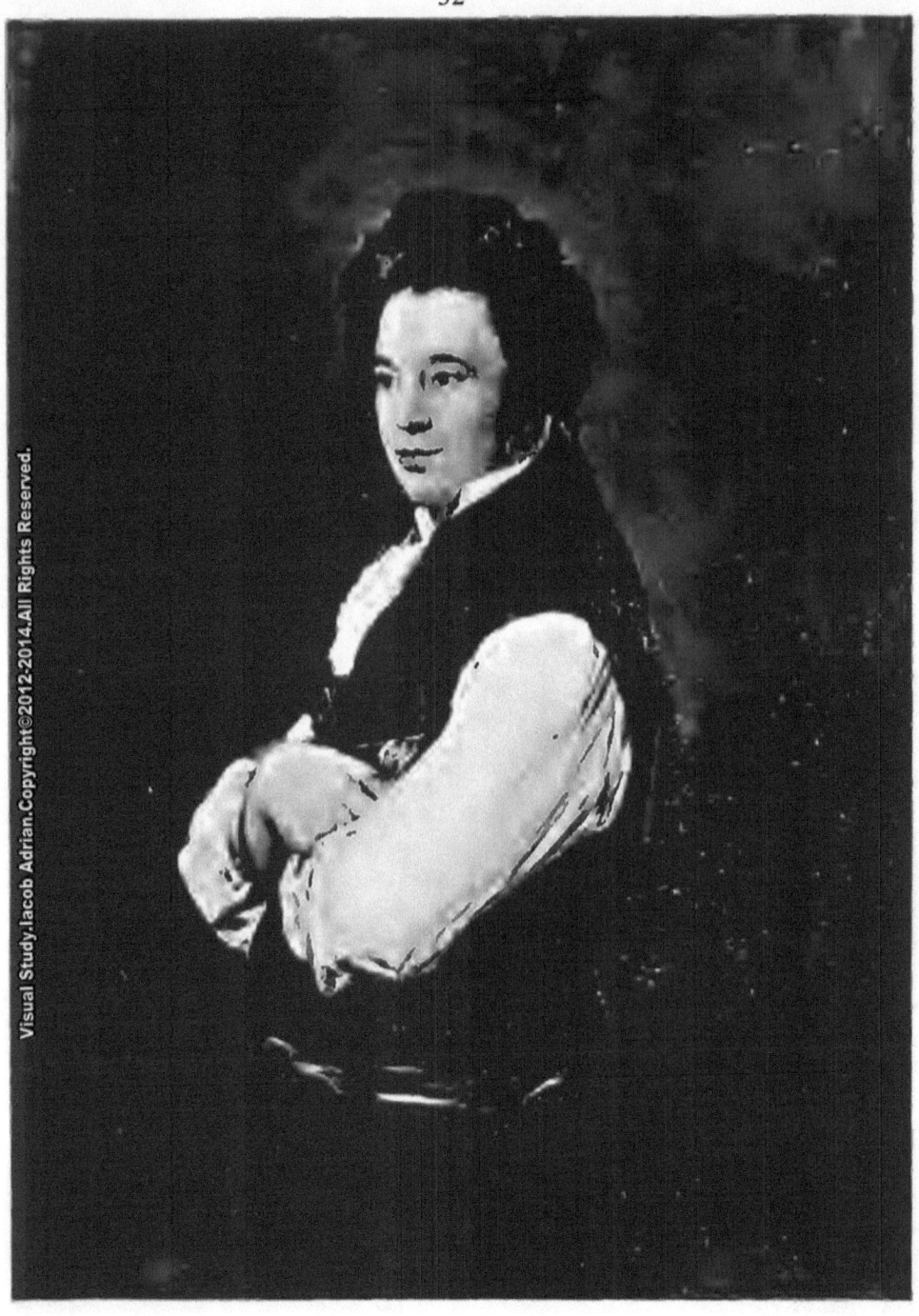

Don Tiburcio Pérez
(*Don F. Durán y Cuervo*)
M. Moreno, Photo.

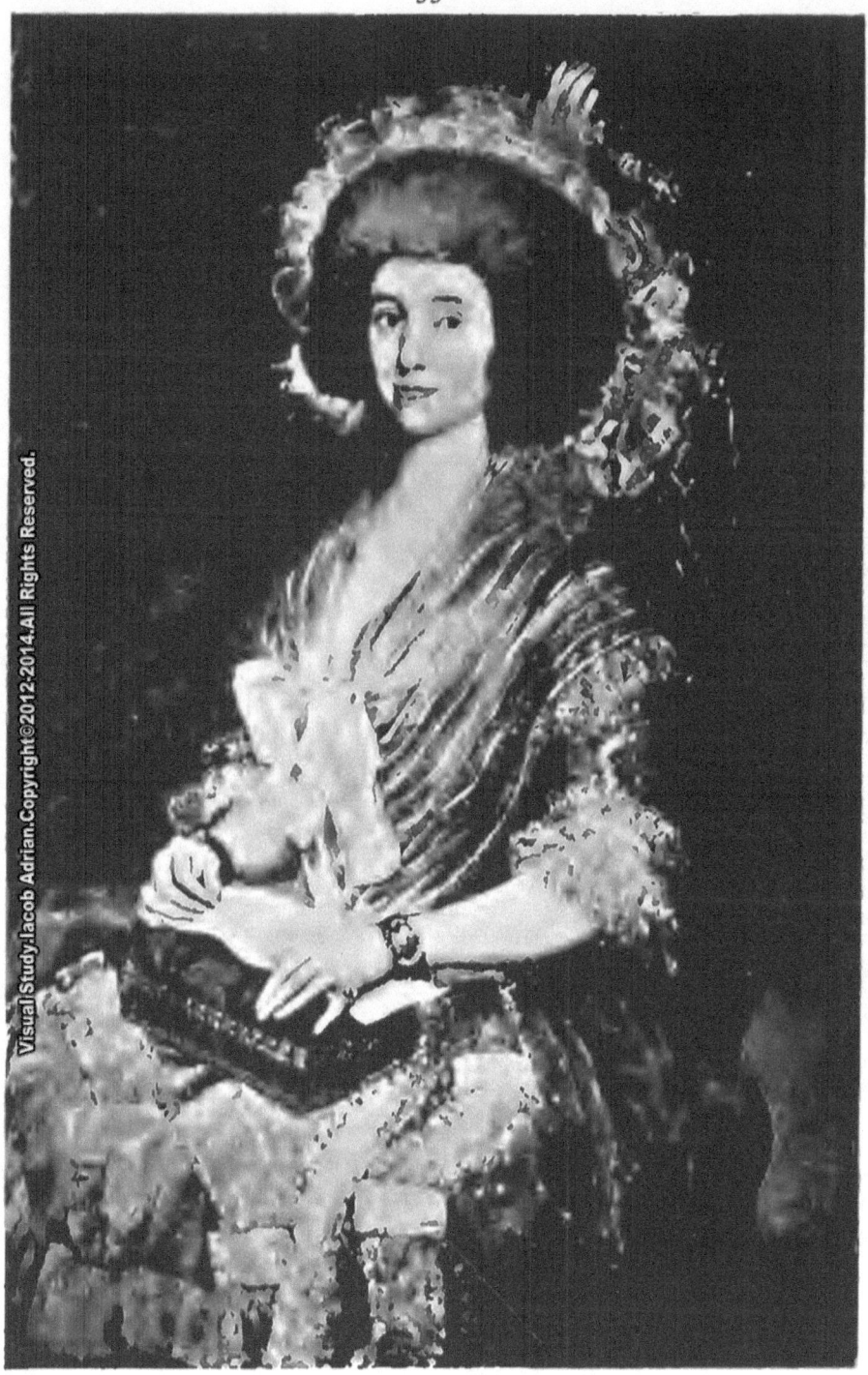

SEÑORA DE CEAN BERMÚDEZ
(El Marqués de Casa Torres)
F. Hanfstaengl, Photo.

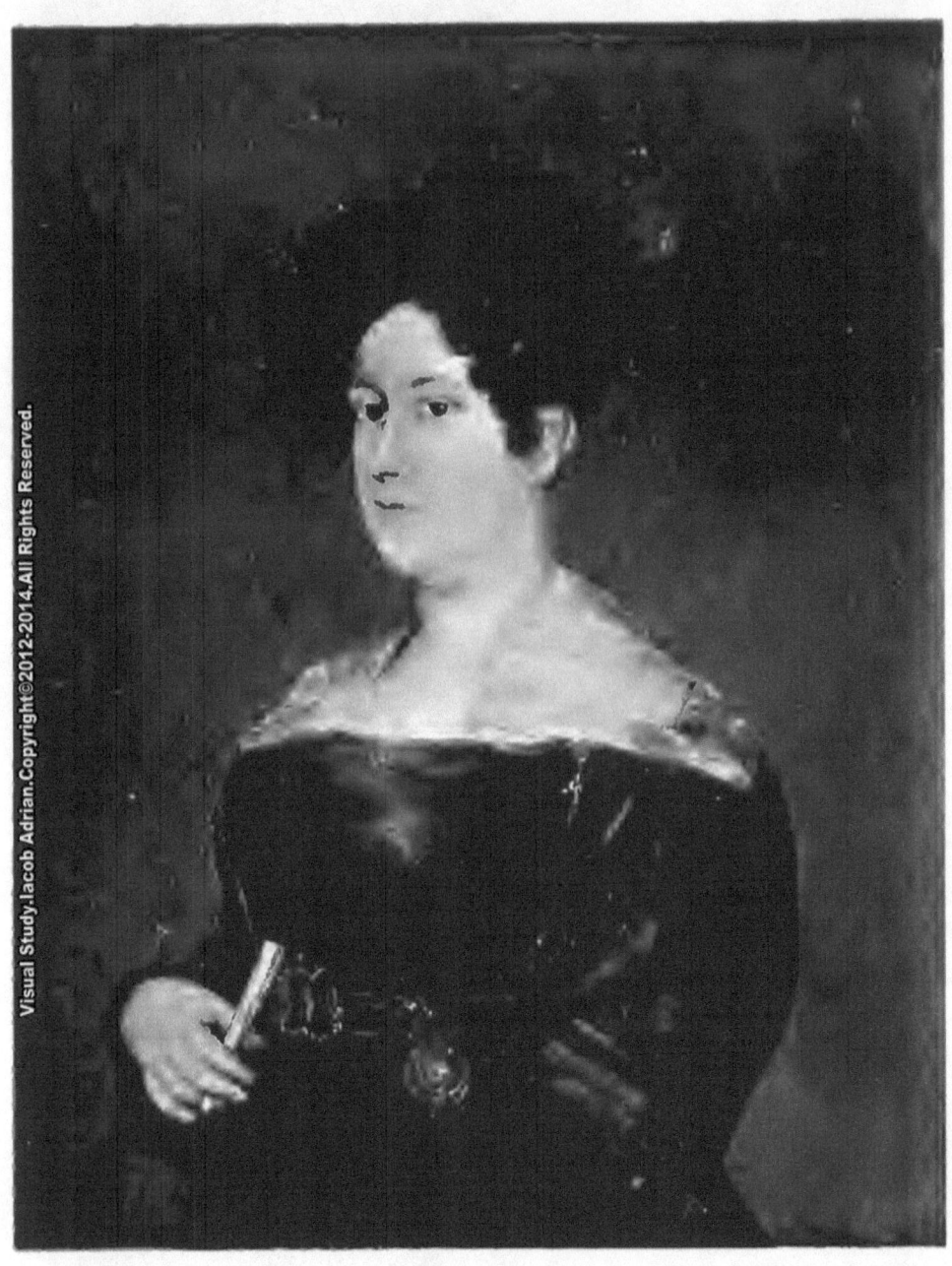

DONNA MANUELA DE ALVAREZ COIÑAS
(*El Marqués de Baroja*)
M. Moreno, Photo.

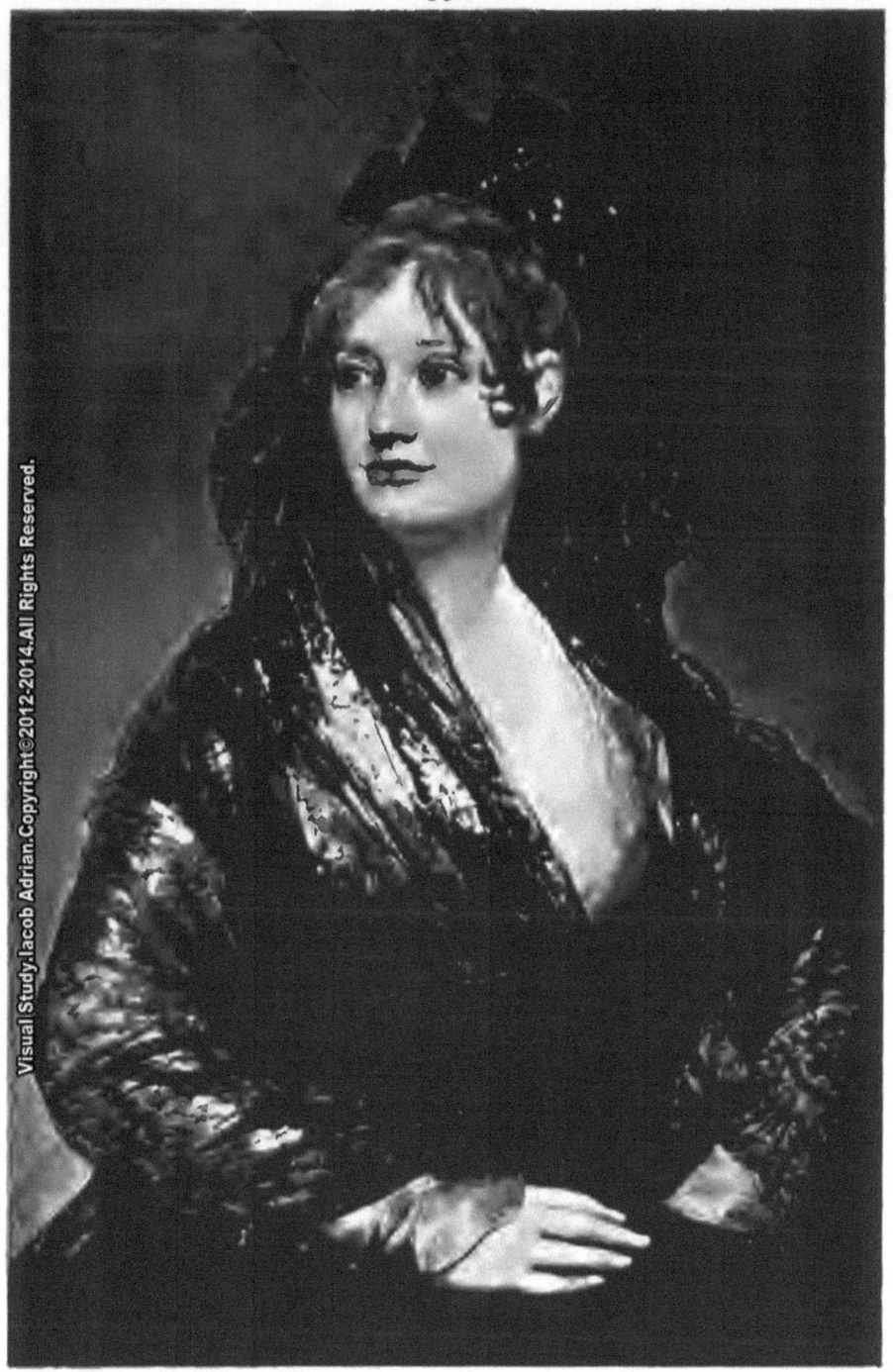

DONNA ISABEL COBOS DE PORCEL
(National Gallery, London) (Galerie nationale, Londres)
(London, Nationalgalerie)
F. Hanfstaengl, Photo.

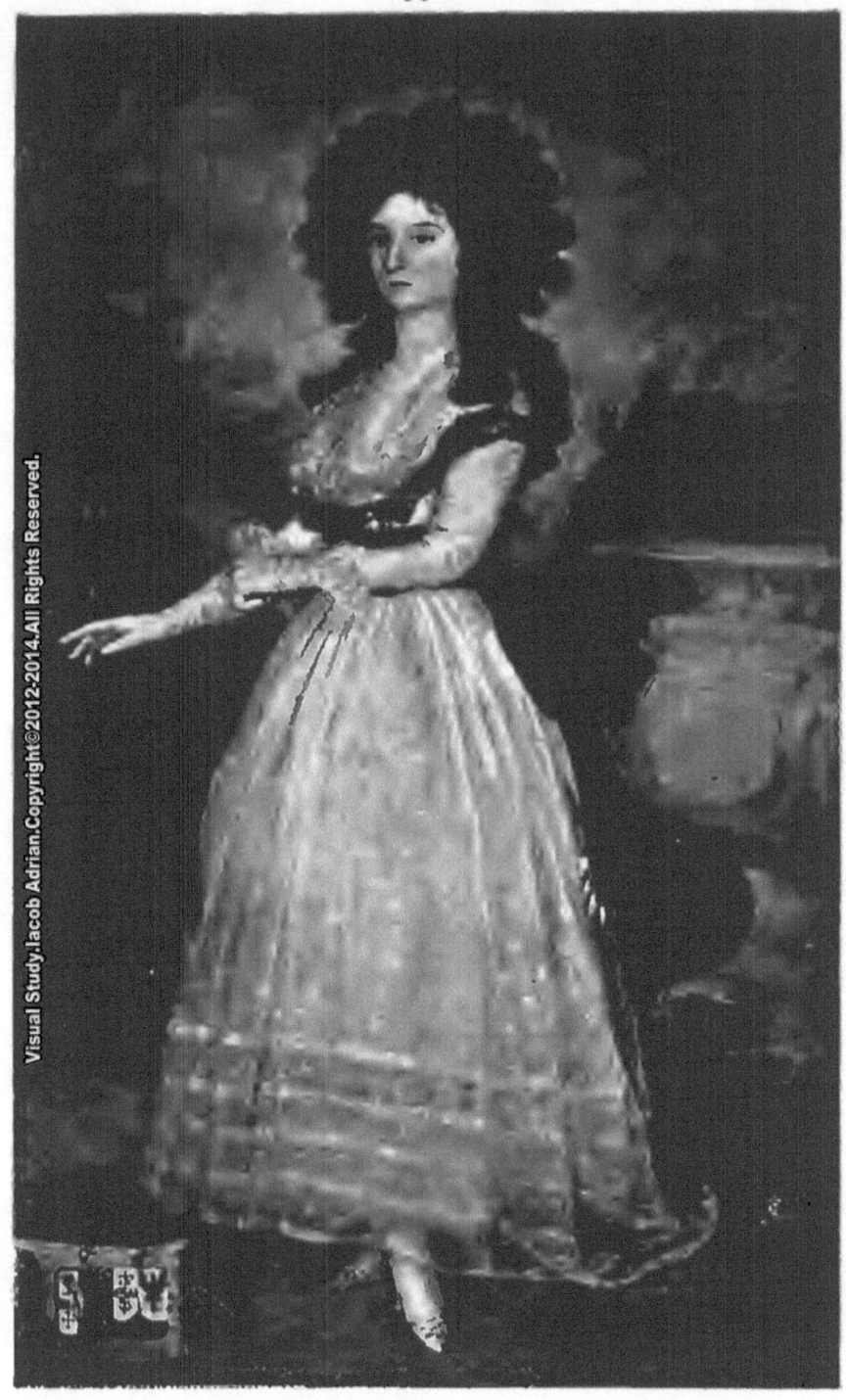

DONNA TADEA ARIAS DE ENRIQUEZ
(*Prado, Madrid*)
D. Anderson, Photo.

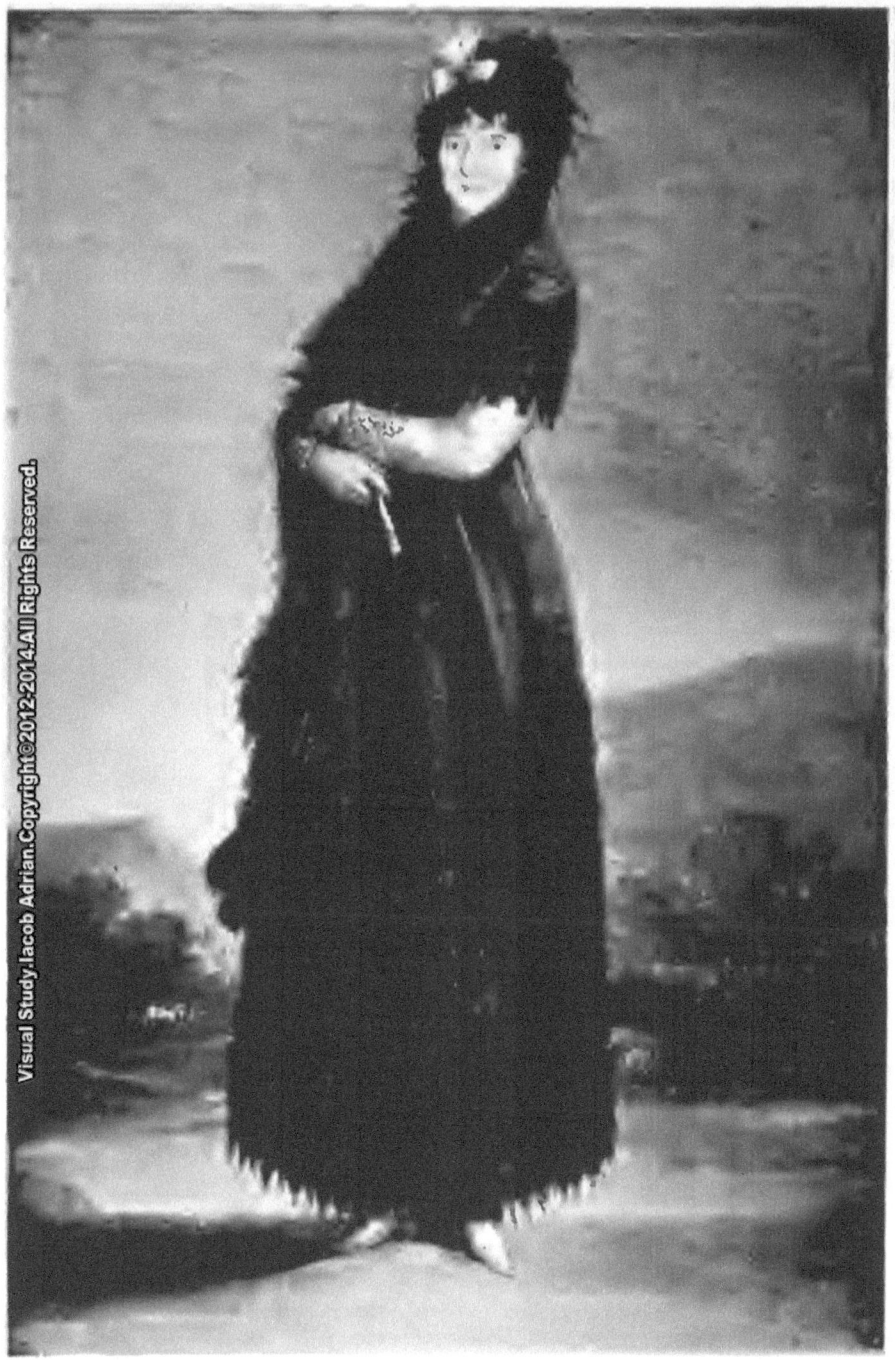

PORTRAIT OF A LADY
(*Louvre, Paris*)

PORTRAIT DE DAME
(*Louvre, Paris*)

BILDNIS EINER DAME
(*Paris, Louvre*)

Lévy et son Fils, Photo.

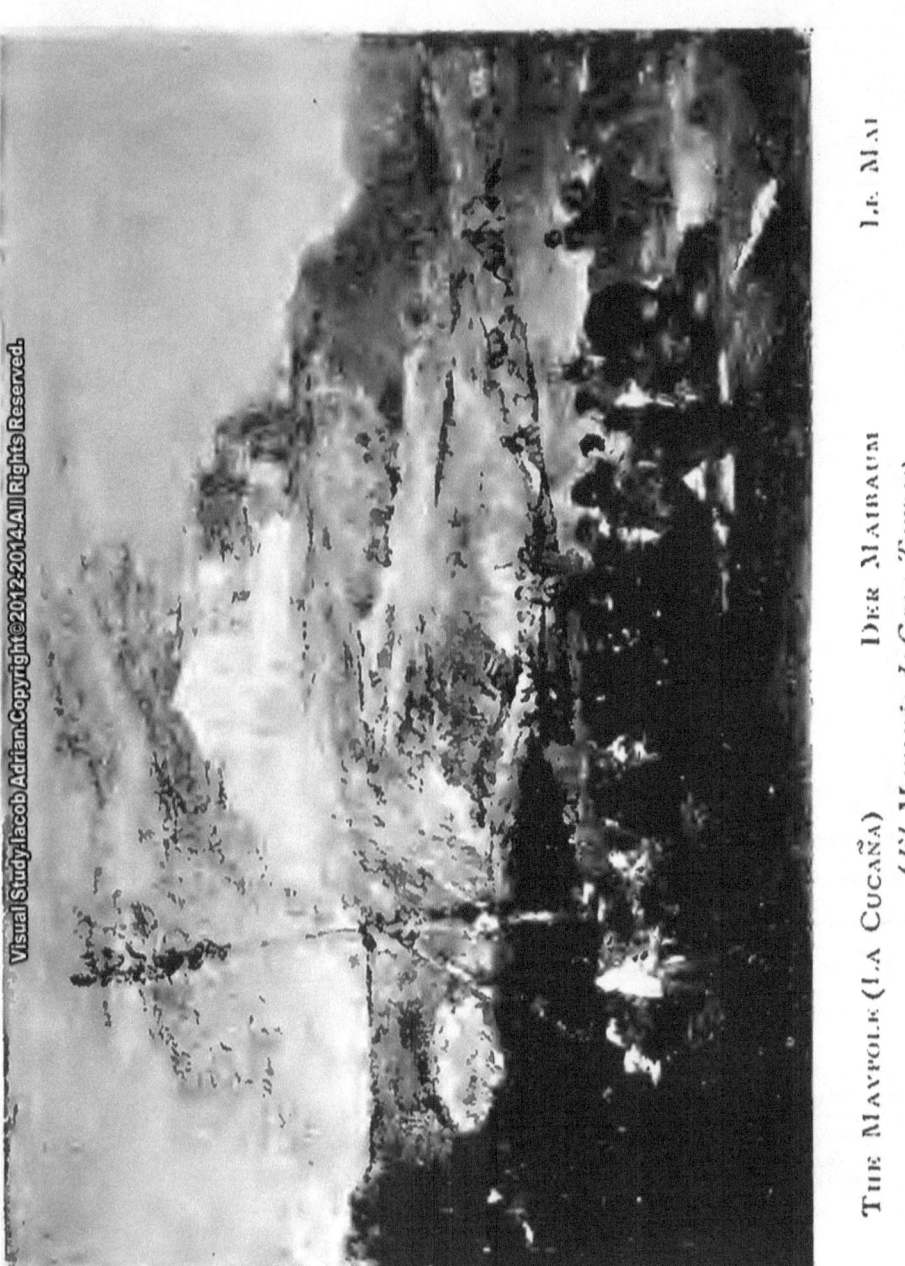

THE MAYPOLE (LA CUCAÑA) DER MAIBAUM LE MAI
(*El Marqués de Casa Torres*)
M. Moreno, Photo.

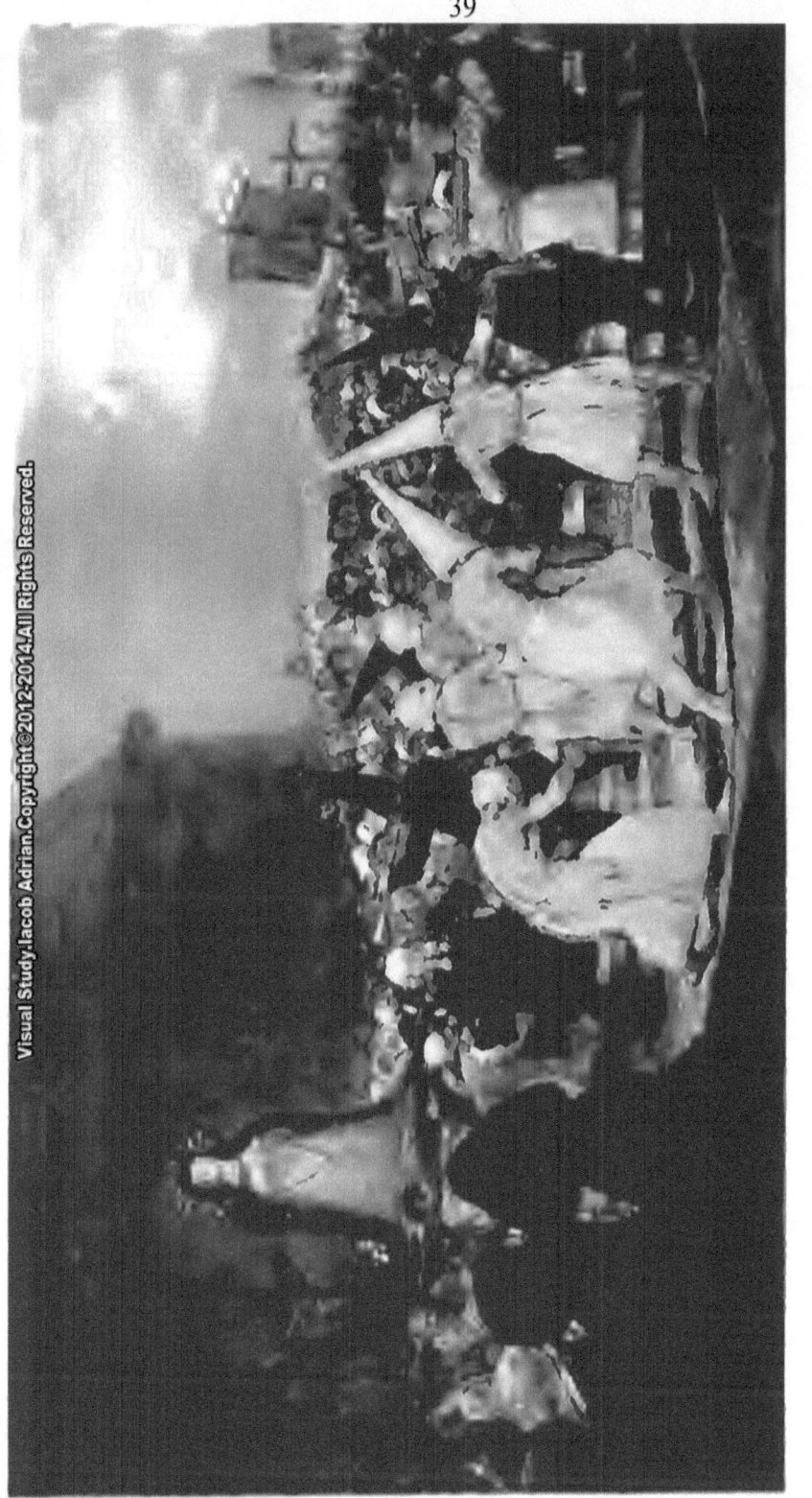

A Procession
(Academy of St. Ferdinand, Madrid)

Eine Prozession
(Madrid, Akademie des St. Ferdinand)

Une Procession
(Académie de St-Ferdinand, Madrid)

D. Anderson, Photo.

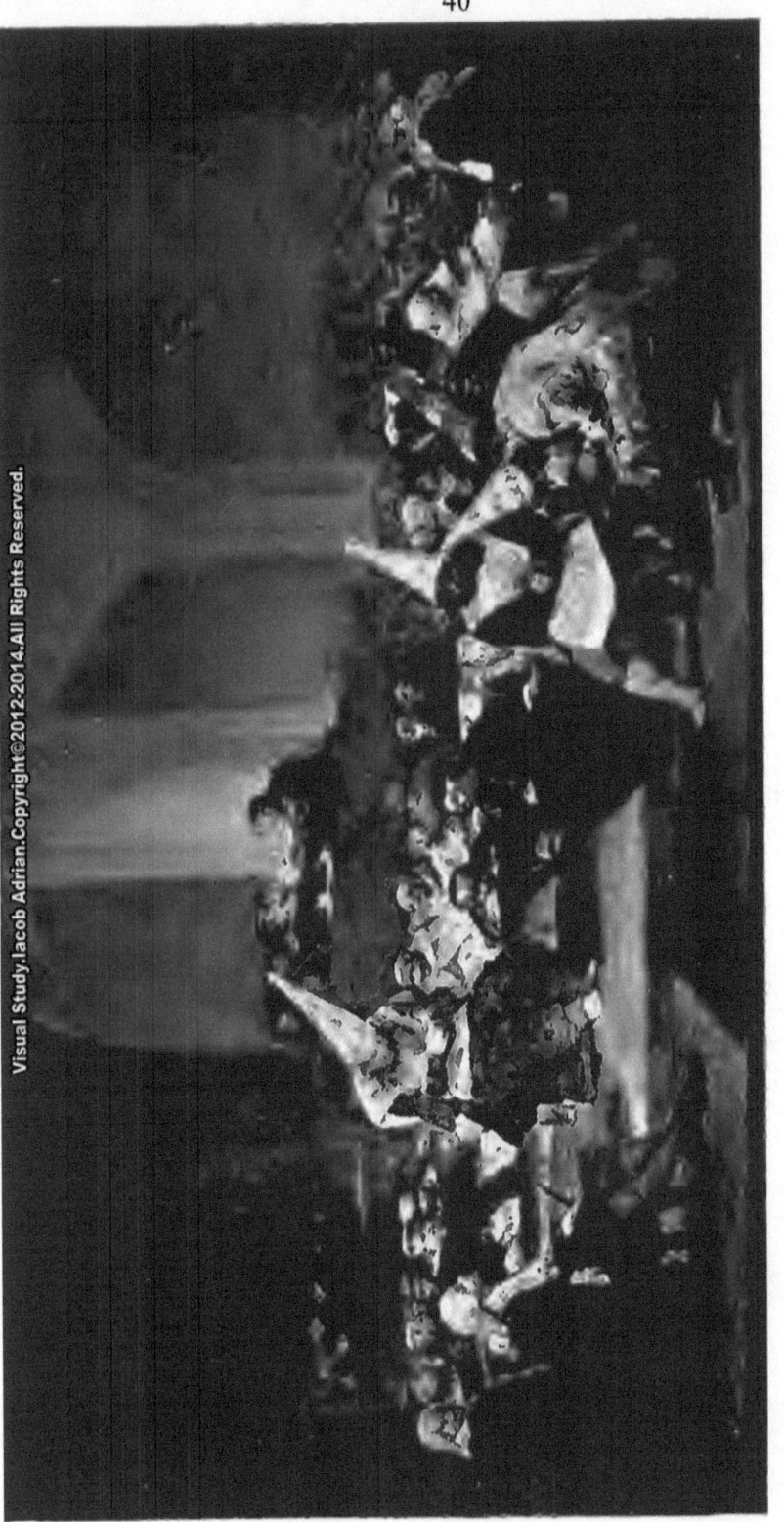

A Sitting of the Inquisition
(Academy of St. Ferdinand, Madrid)

Une Audience de l'Inquisition
(Académie de St-Ferdinand, Madrid)

Gerichtssitzung der Inquisition
(Madrid, Akademie des St. Ferdinand)

D. Anderson, Photo.

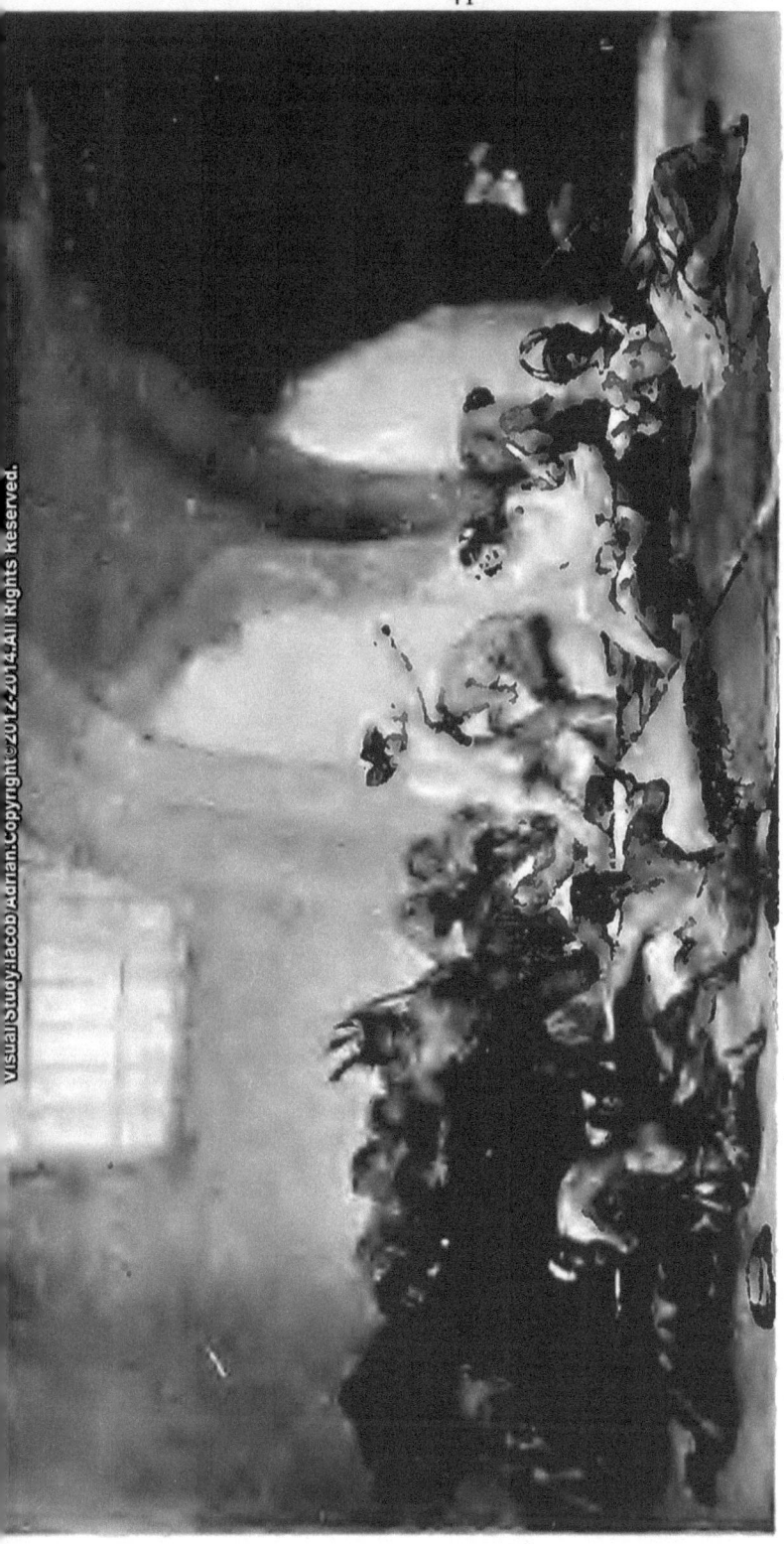

THE MADHOUSE LA MAISON DE FOUS
(Academy of St. Ferdinand, Madrid) (Académie de St-Ferdinand, Madrid)
DAS IRRENHAUS
(Madrid, Akademie des St. Ferdinand) D. Anderson, Photo.

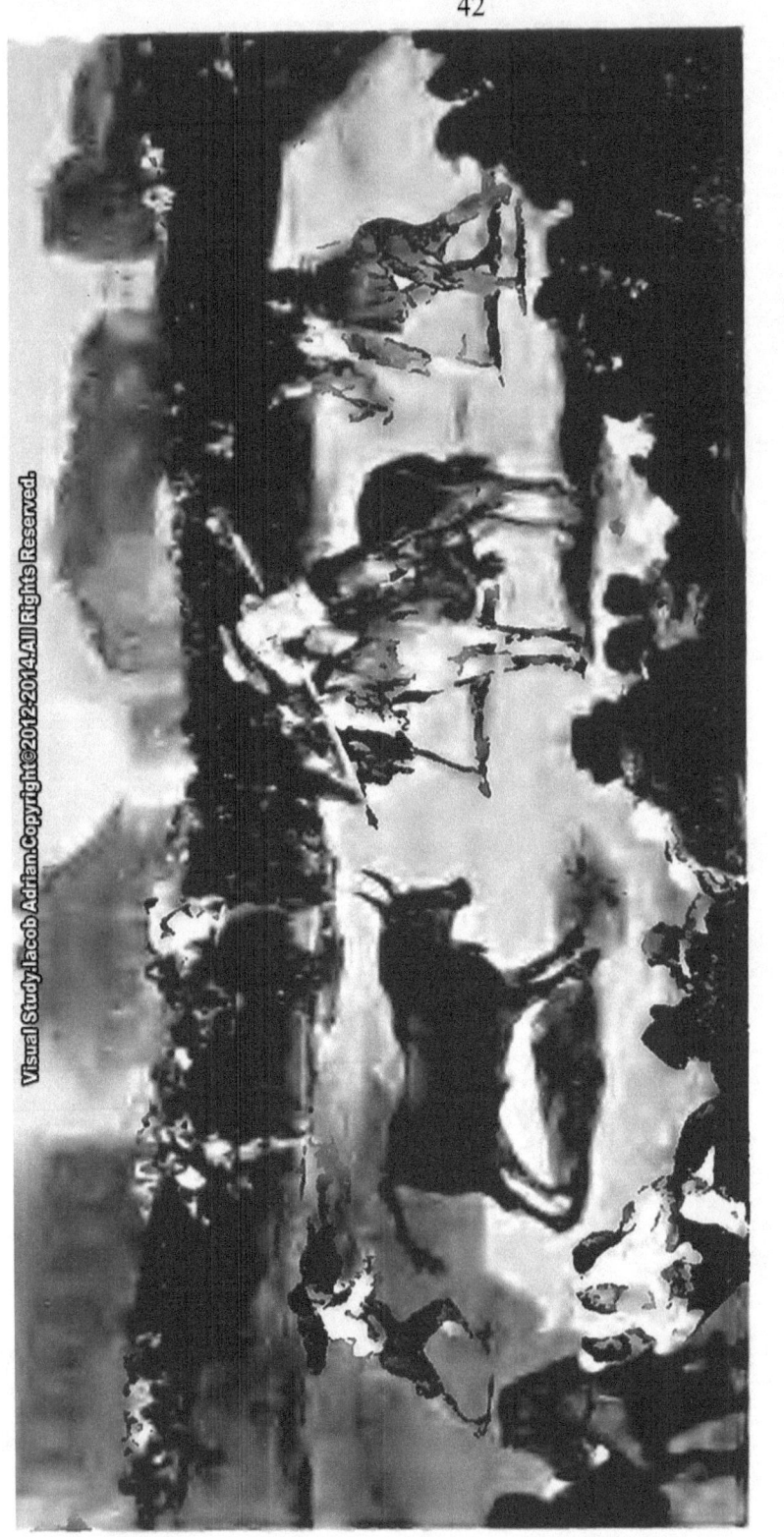

A Bull-Fight
(Academy of St. Ferdinand, Madrid)

Une Course de Taureaux
(Académie de St-Ferdinand, Madrid)

Ein Stierkampf
(Madrid, Akademie des St. Ferdinand)

D. Anderson, Photo.

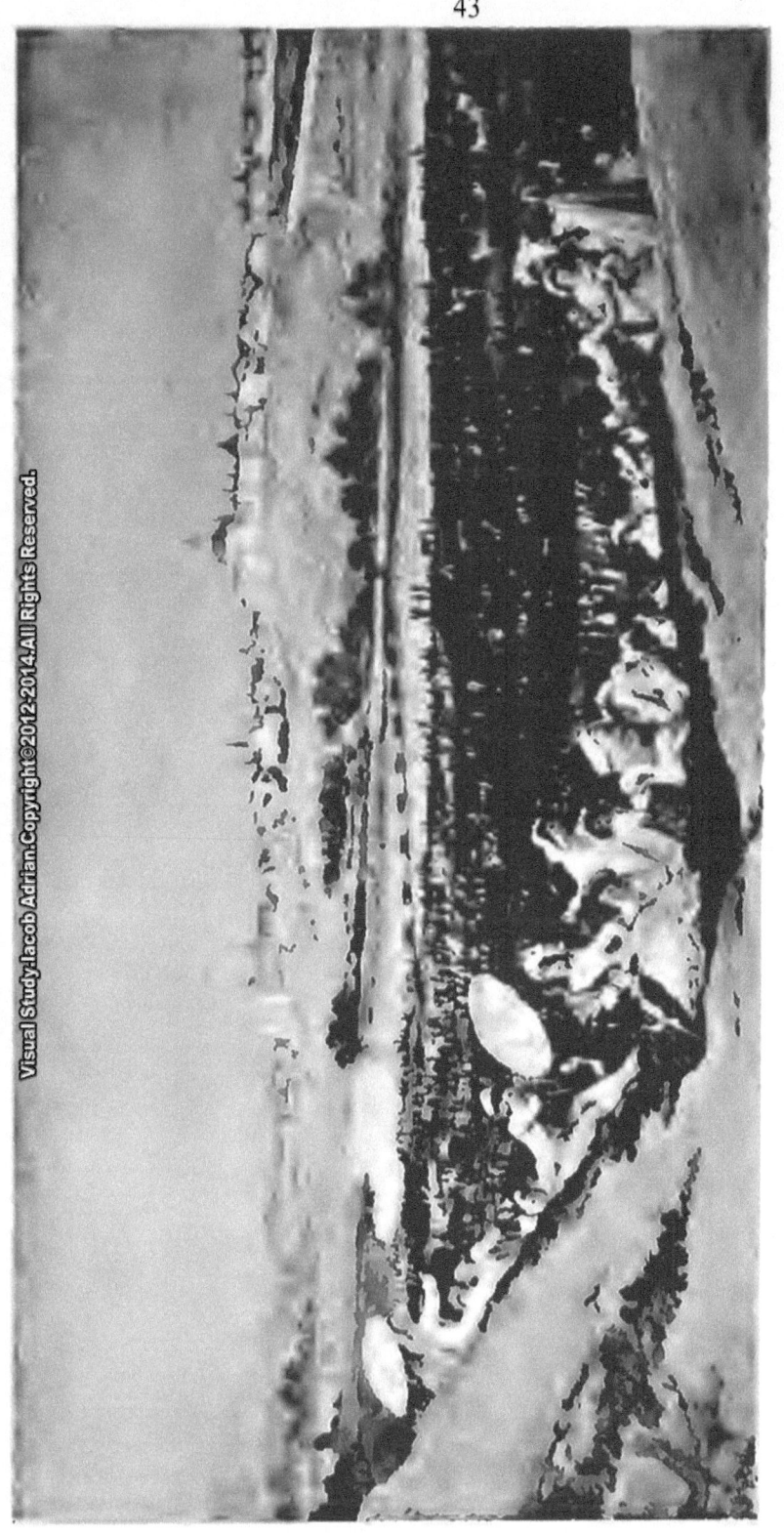

THE MEADOW OF ST. ISIDORE DIE WIESE DES HL. ISIDORUS LE PRÉ DE ST-ISIDORE
(*Prado, Madrid*) (*Madrid, Prado*) (*Prado, Madrid*)

F. Hanfstaengl, Photo.

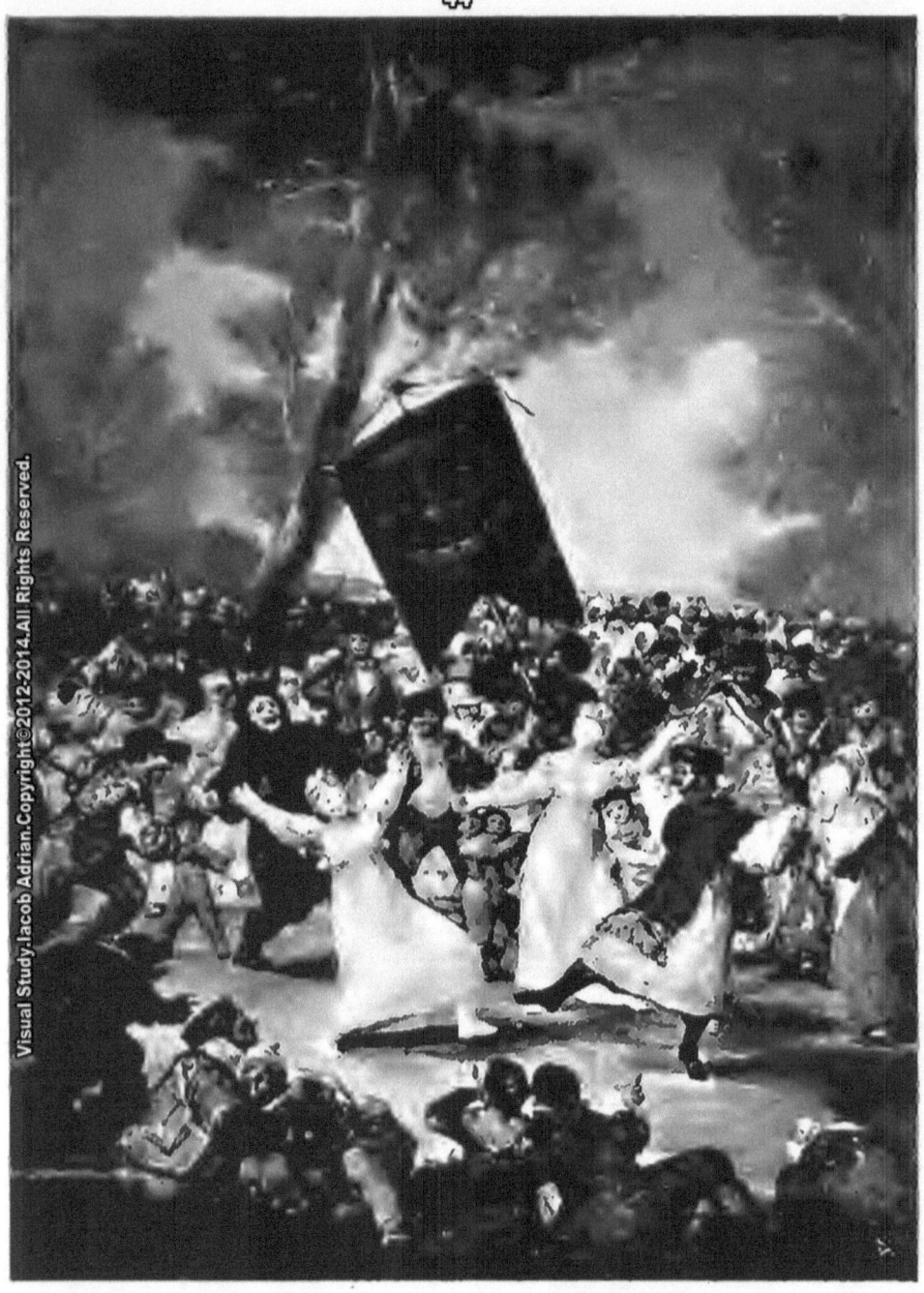

CARNIVAL SCENE
(Academy of St. Ferdinand, Madrid)

SCÈNE DE CARNAVAL
(Académie de St-Ferdinand, Madrid)

KARNEVALSZENE
(Madrid, Akademie des St. Ferdinand)

D. Anderson, Photo.

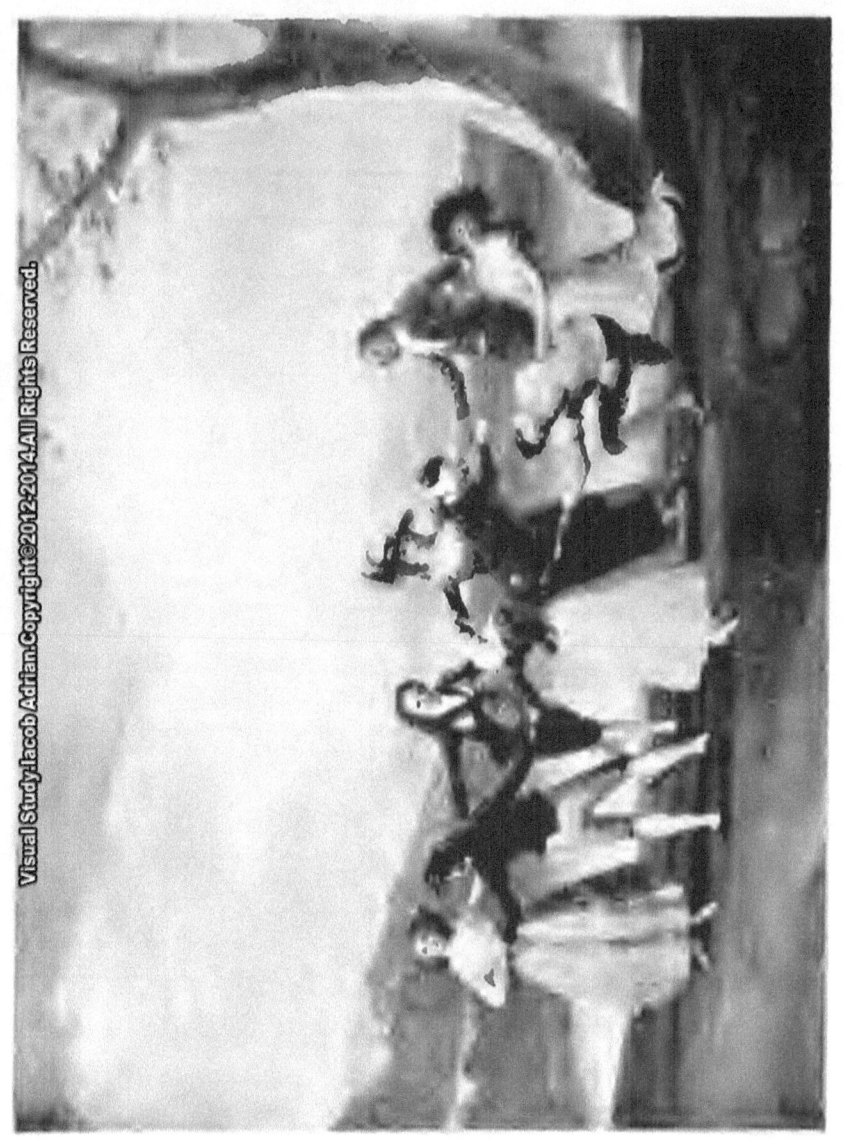

BLIND-MAN'S-BUFF DAS BLINDEKUHSPIEL LE COLIN-MAILLARD
(Prado, Madrid) (Madrid, Prado) (Prado, Madrid)
F. Hanfstaengl, Photo.

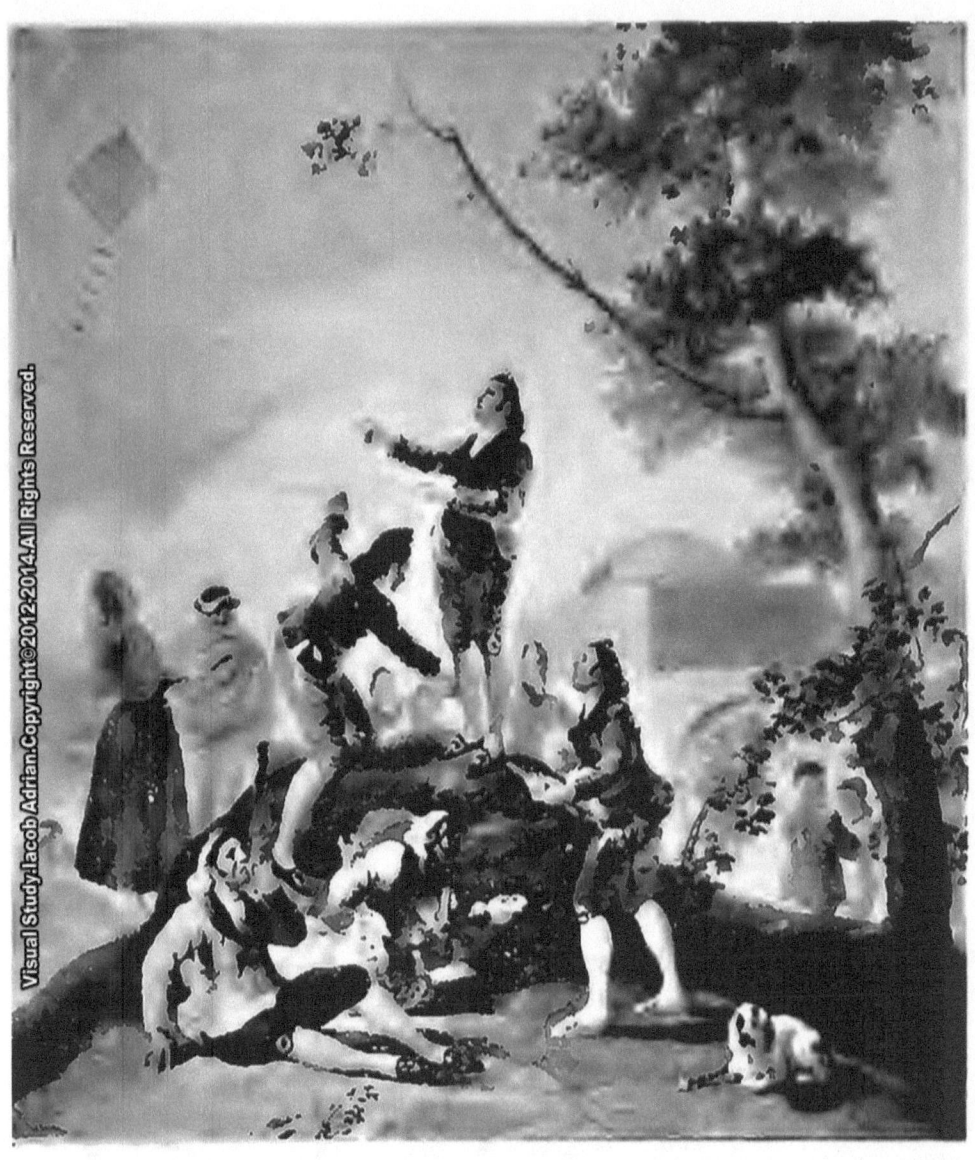

THE KITE DER DRACHEN LE CERF-VOLANT
(Prado, Madrid) (Madrid, Prado) (Prado, Madrid)
F. Hanfstaengl, Photo.

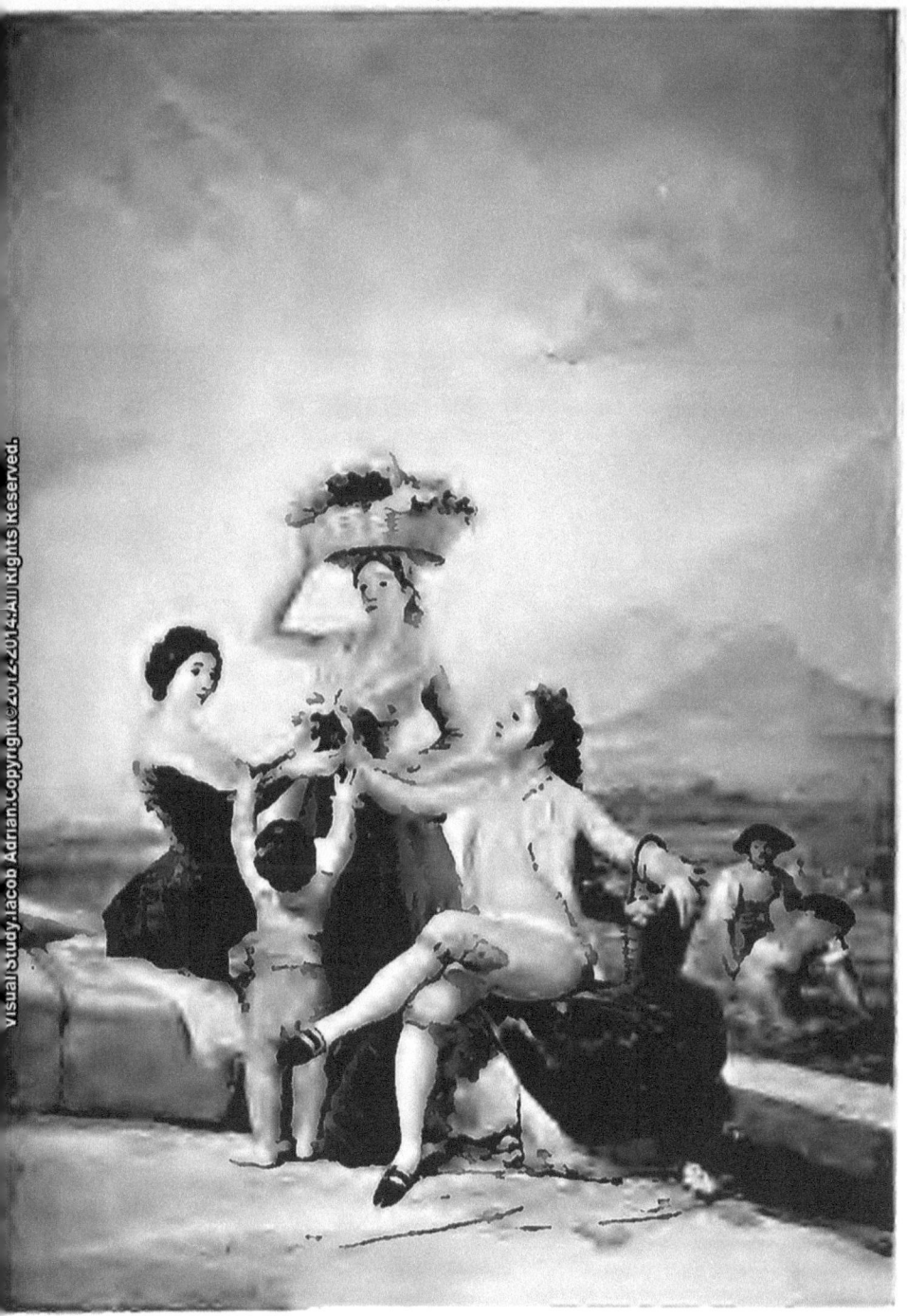

THE VINTAGE DIE WEINLESE LES VENDANGES
(Prado, Madrid) (Madrid, Prado) (Prado, Madrid)
F. Hanfstaengl, Photo.

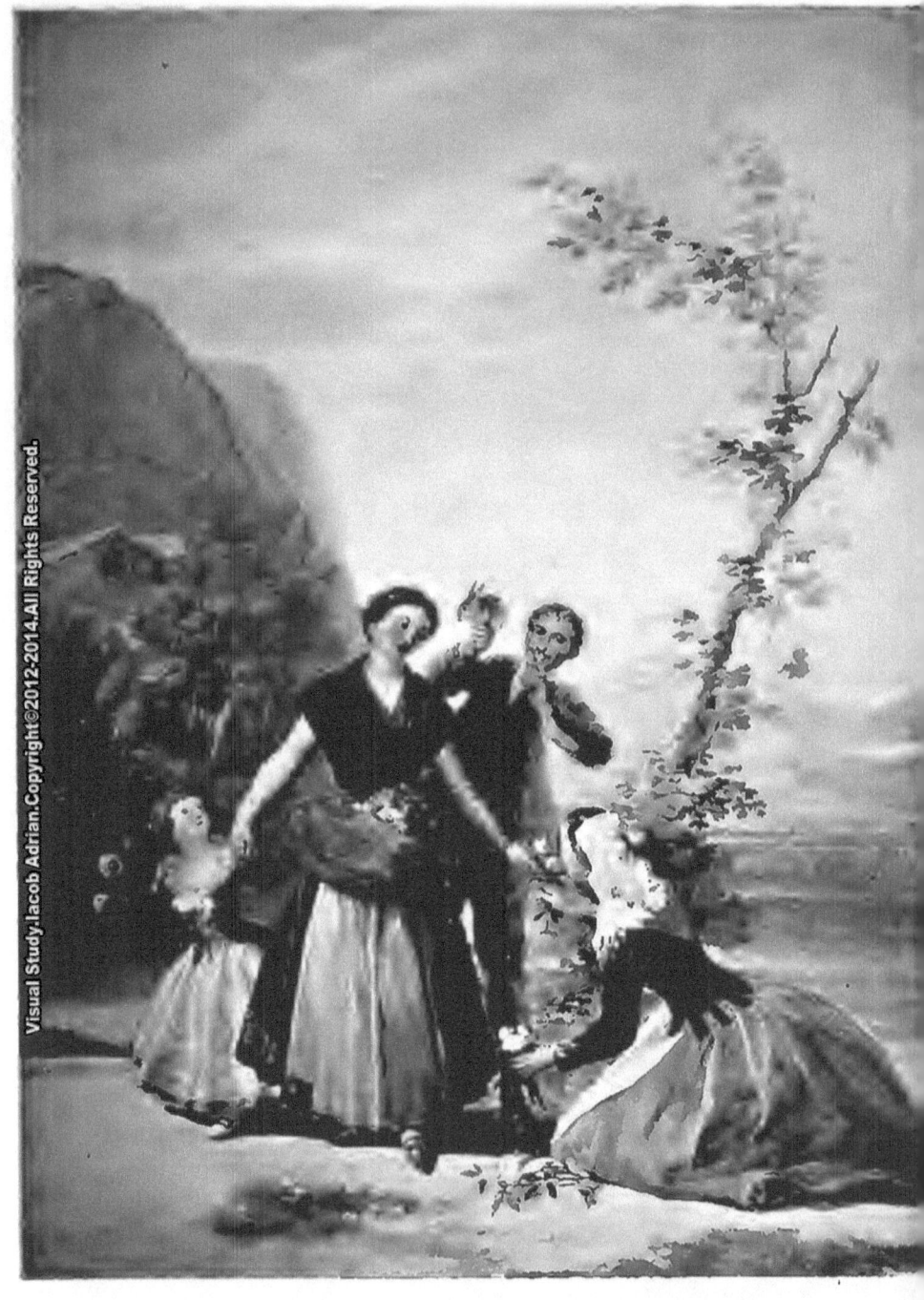

THE FLOWER-GIRLS
(*Prado, Madrid*)

LES VENDEUSES DE FLEURS
(*Prado, Madrid*)

DIE BLUMENMÄDCHEN
(*Madrid, Prado*)

F. Hanfstaengl, Photo.

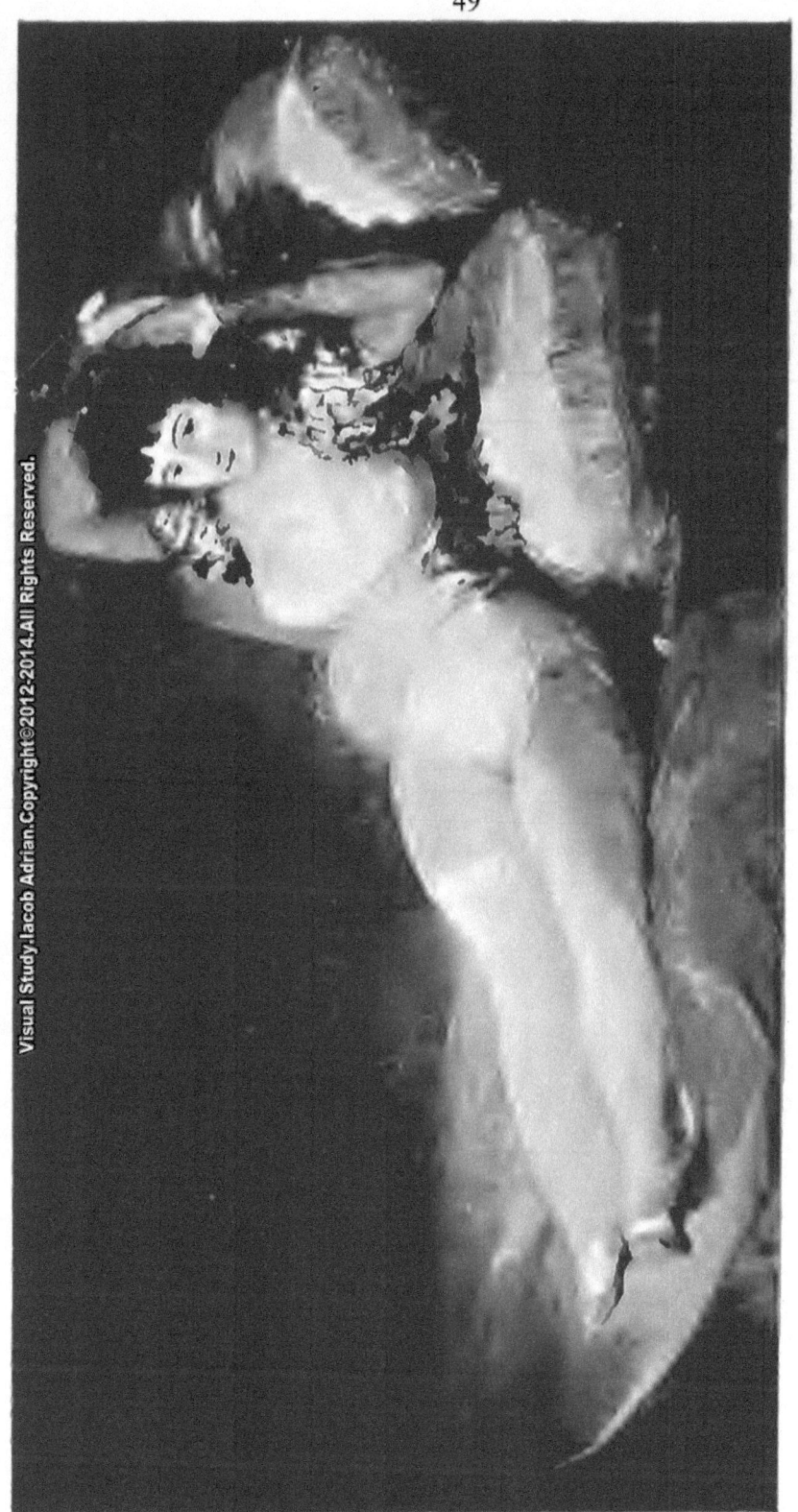

MAJA, CLOTHED
(*Prado, Madrid*)

MAJA, BEKLEIDET
(*Madrid, Prado*)

MAJA, VÊTUE
(*Prado, Madrid*)

F. *Hanfstaengl, Photo.*

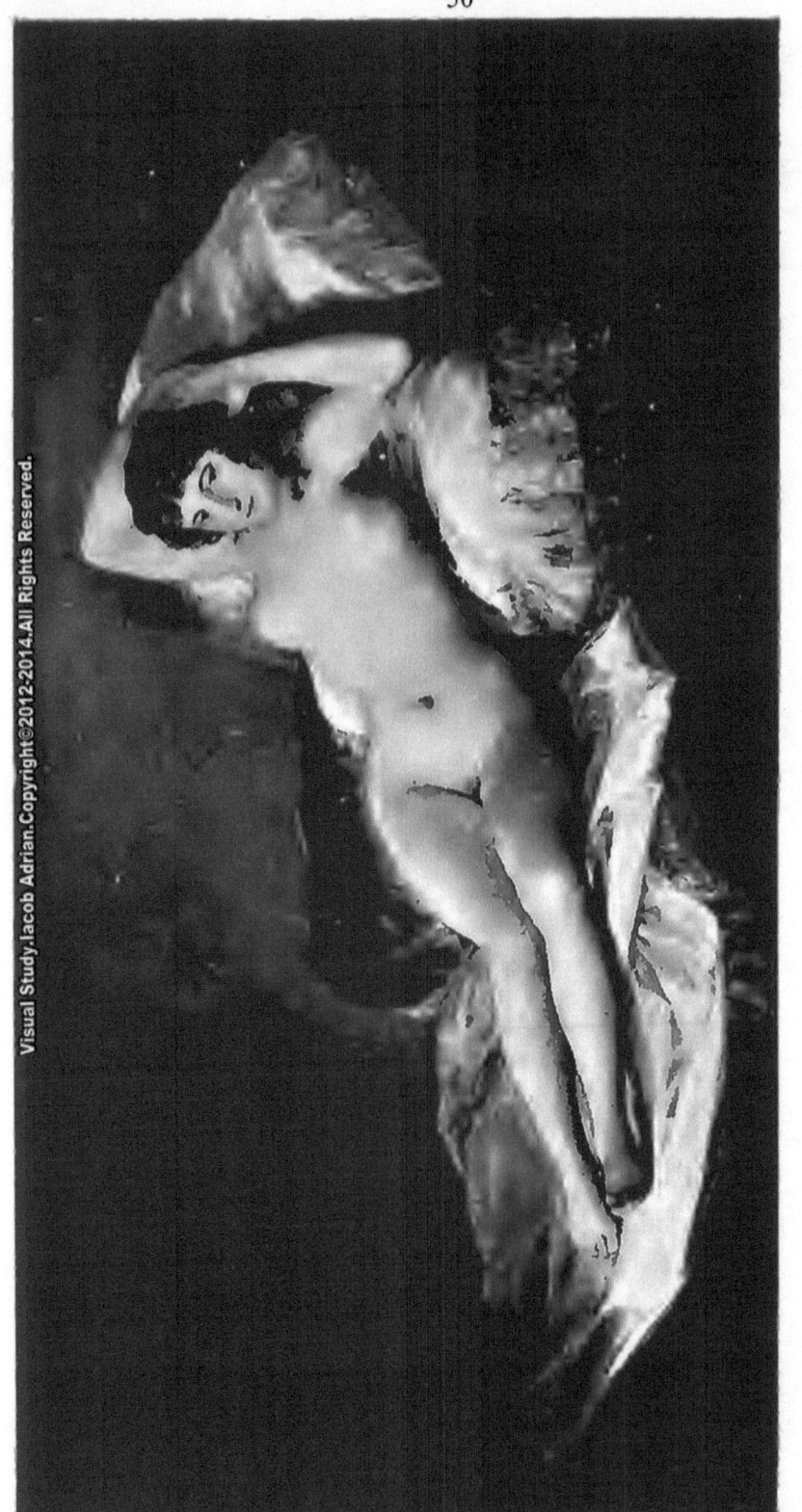

MAJA, NUE
(Prado, Madrid)

MAJA, NACKT
(Madrid, Prado)
F. Hanfstaengl, Photo.

MAJA, NUE
(Prado, Madrid)

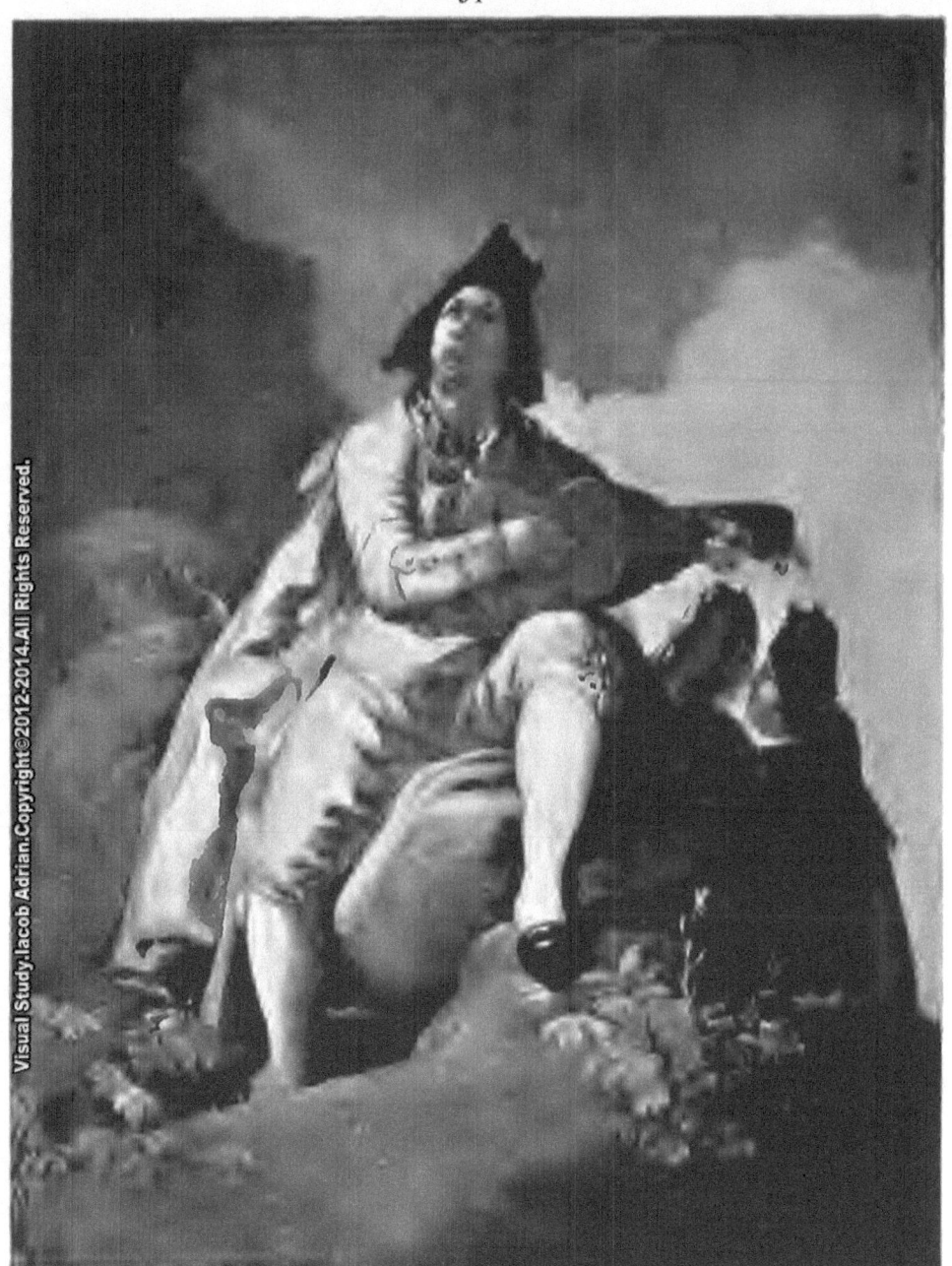

THE GUITAR-PLAYER
(*Prado, Madrid*)

LE JOUEUR DE GUITARE
(*Prado, Madrid*)

DER GUITARRESPIELER
(*Madrid, Prado*)

F. Hanfstaengl, Photo.

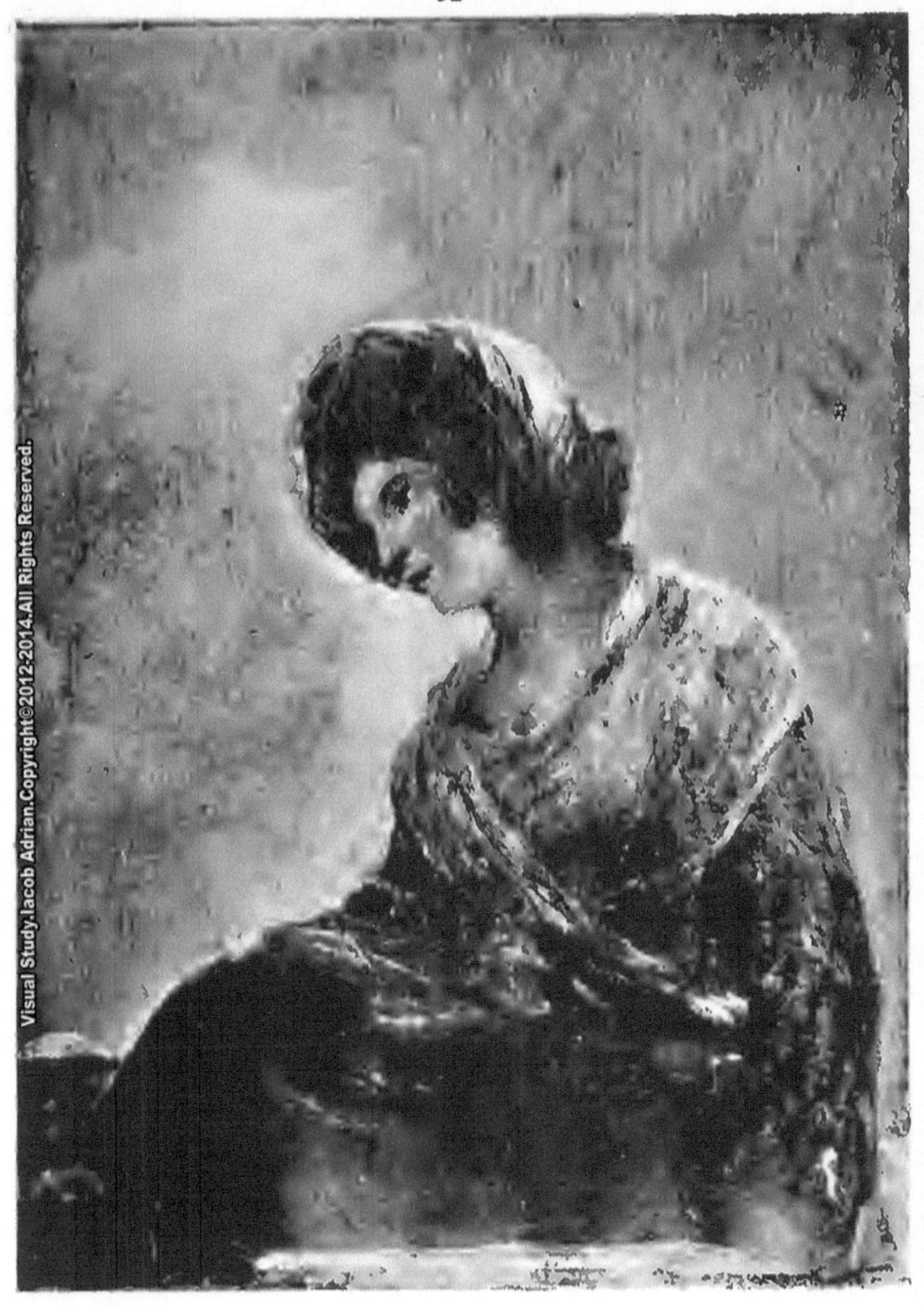

THE MILKMAID DAS MILCHMÄDCHEN LA LAITIÈRE
(*Condesa Viuda de Muguiro*)
M. Moreno, Photo.

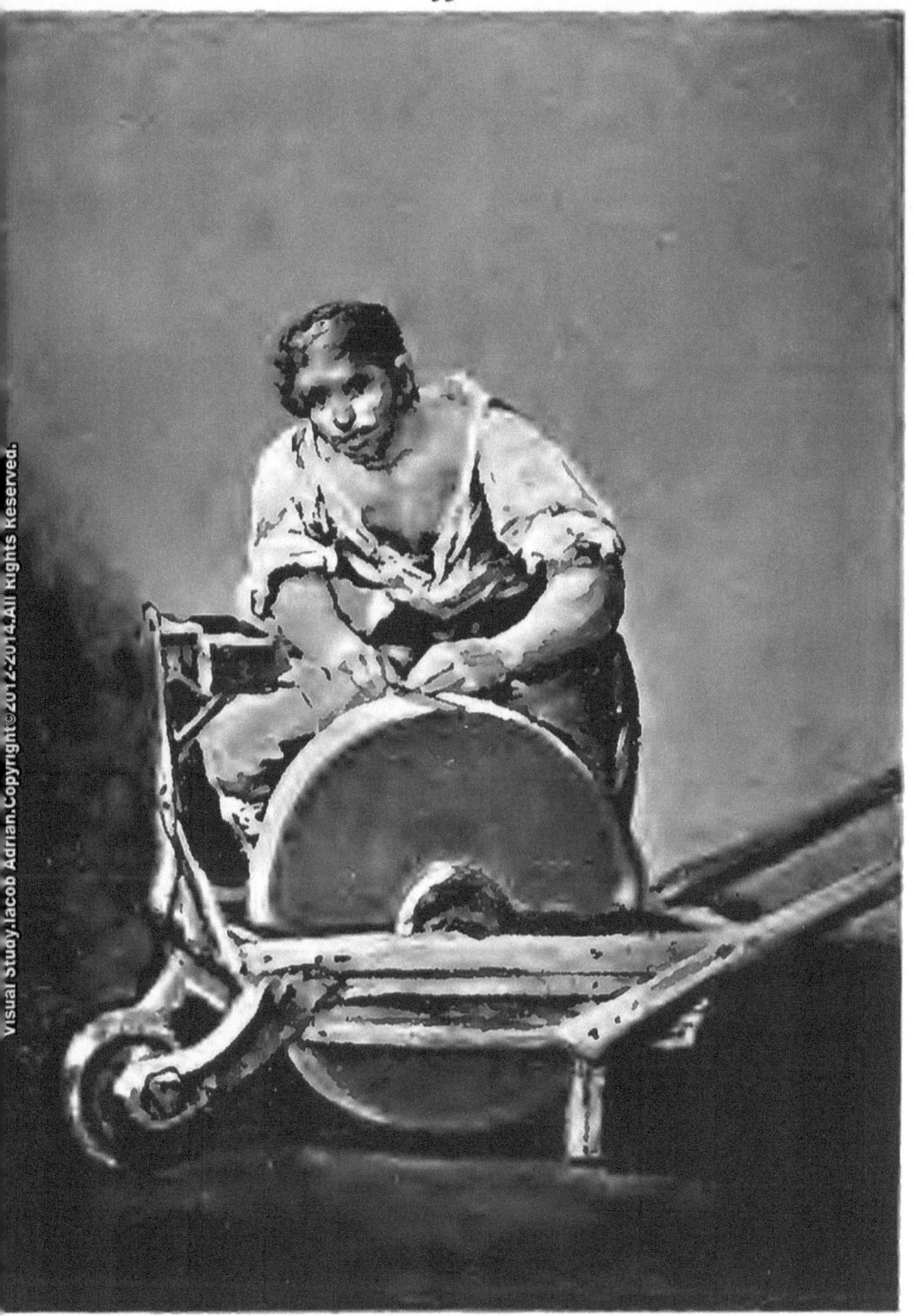

THE KNIFE GRINDER DER MESSERSCHLEIFER L'ÉMOULEUR
(Museum, Buda-Pesth) (Budapest, Museum) (Musée, Buda-Pesth)
F. Hanfstaengl, Photo.

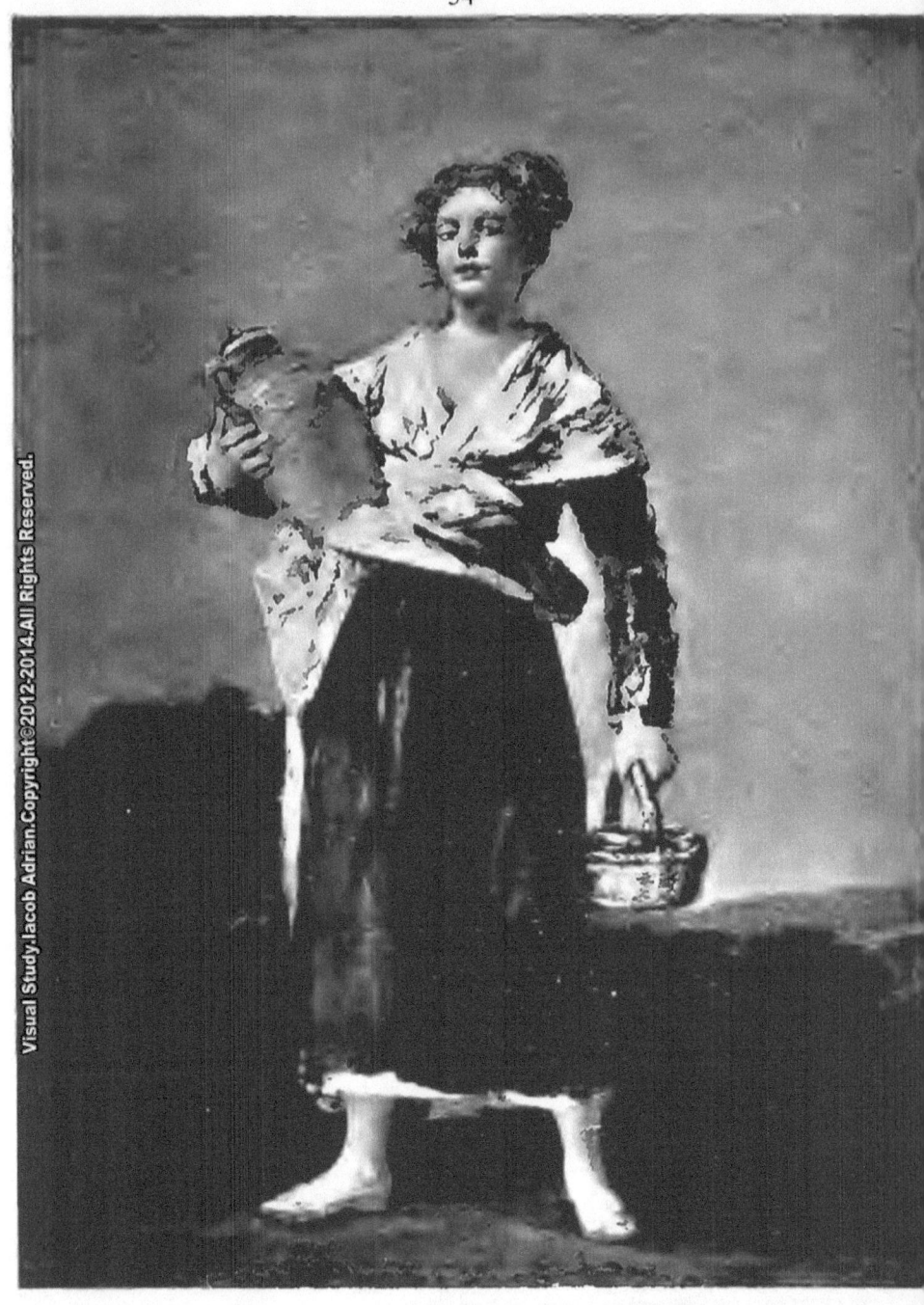

THE WATER-CARRIER
(*Museum, Buda-Pesth*)

LA PORTEUSE D'EAU
(*Musée, Buda-Pesth*)

DIE WASSERTRÄGERIN
(*Budapest, Museum*)

F. Hanfstaengl, Photo.

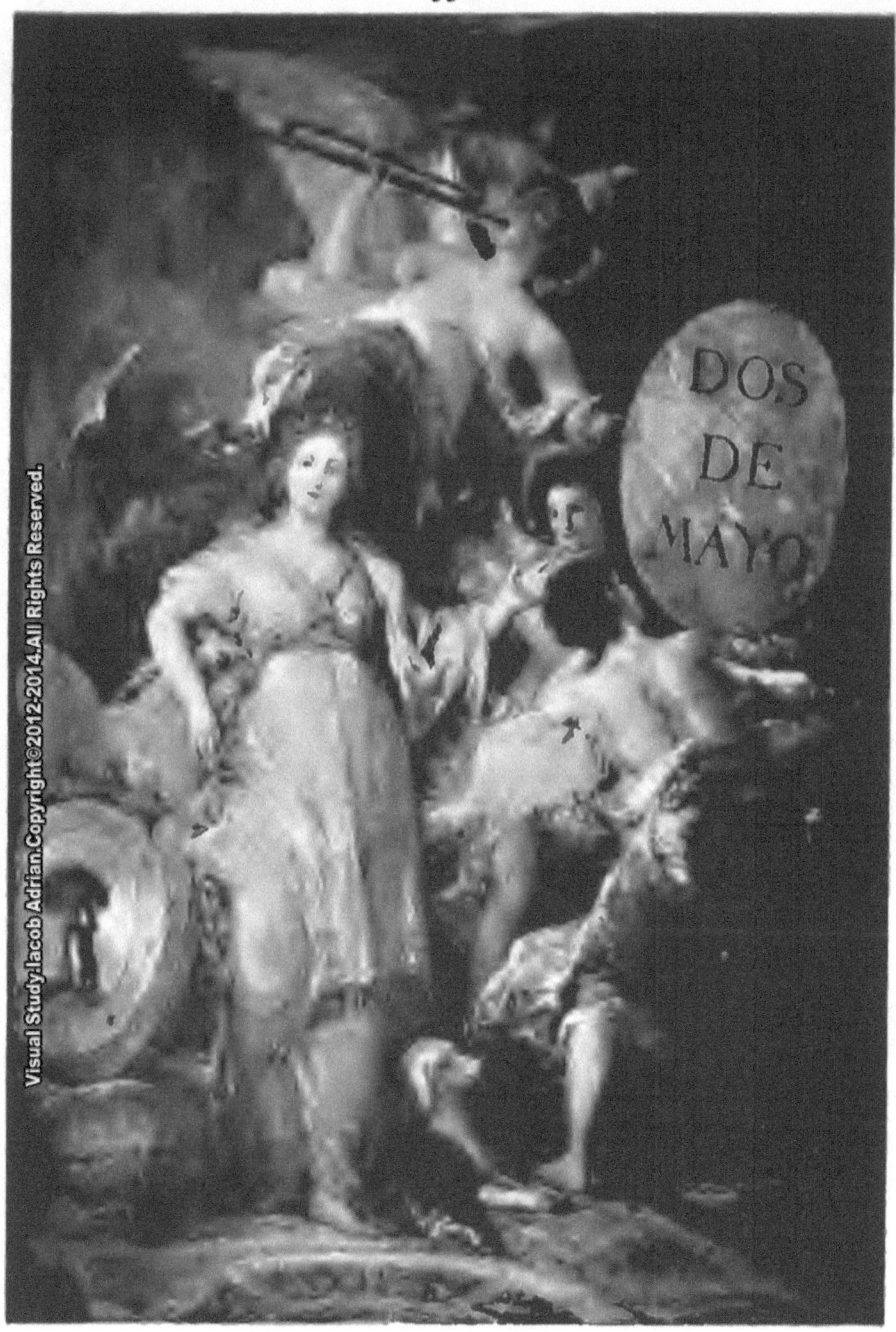

ALLEGORY OF THE CITY OF
MADRID
(Town-Hall, Madrid)

ALLÉGORIE DE LA VILLE DE
MADRID
(Hôtel de Ville, Madrid)

ALLEGORIE DER STADT MADRID
(Madrid, Rathaus)
M. Moreno, Photo.

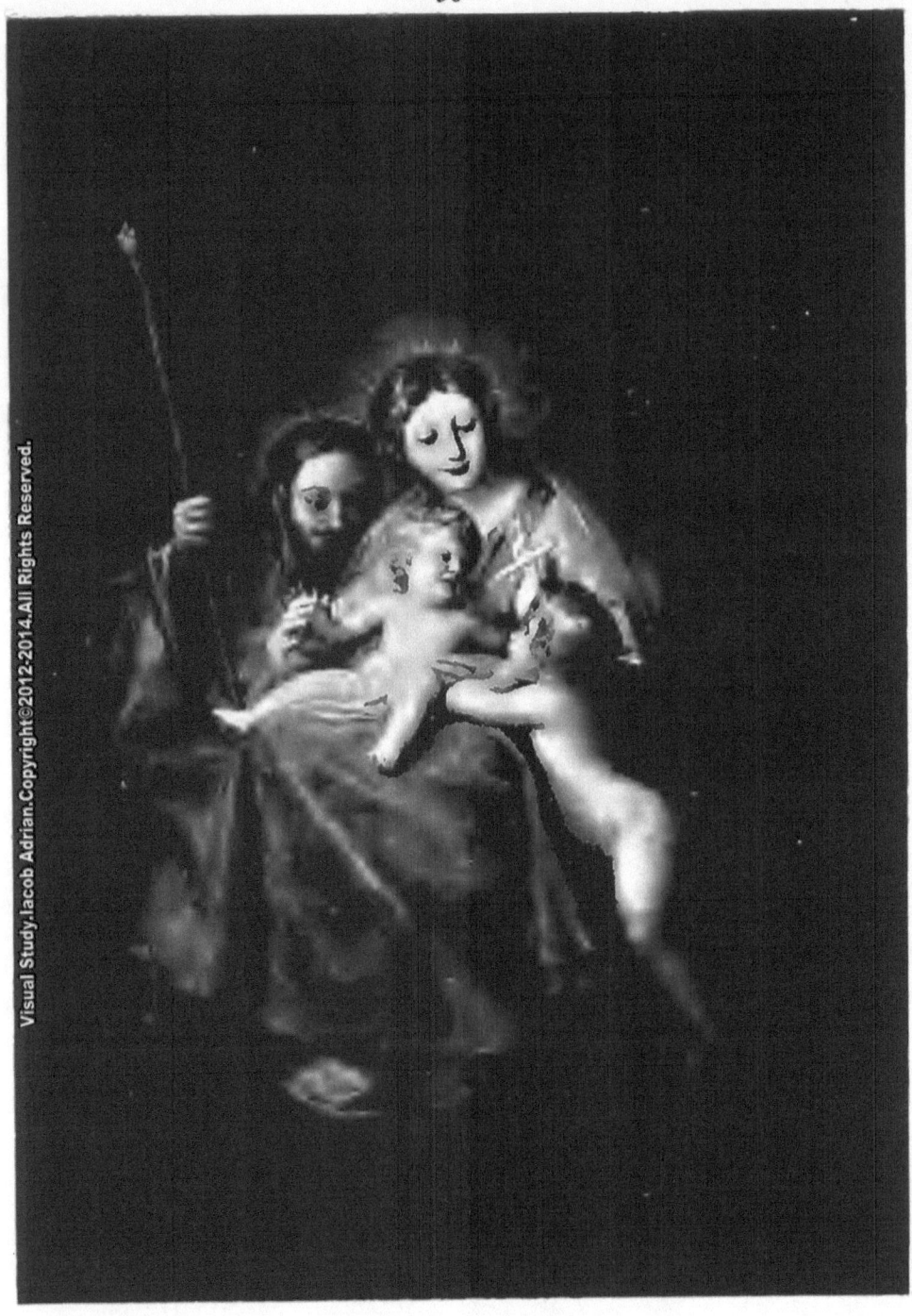

THE HOLY FAMILY DIE HEILIGE FAMILIE LA SAINTE FAMILLE
(Prado, Madrid) (Madrid, Prado) (Prado, Madrid)
 D. Anderson, Photo.

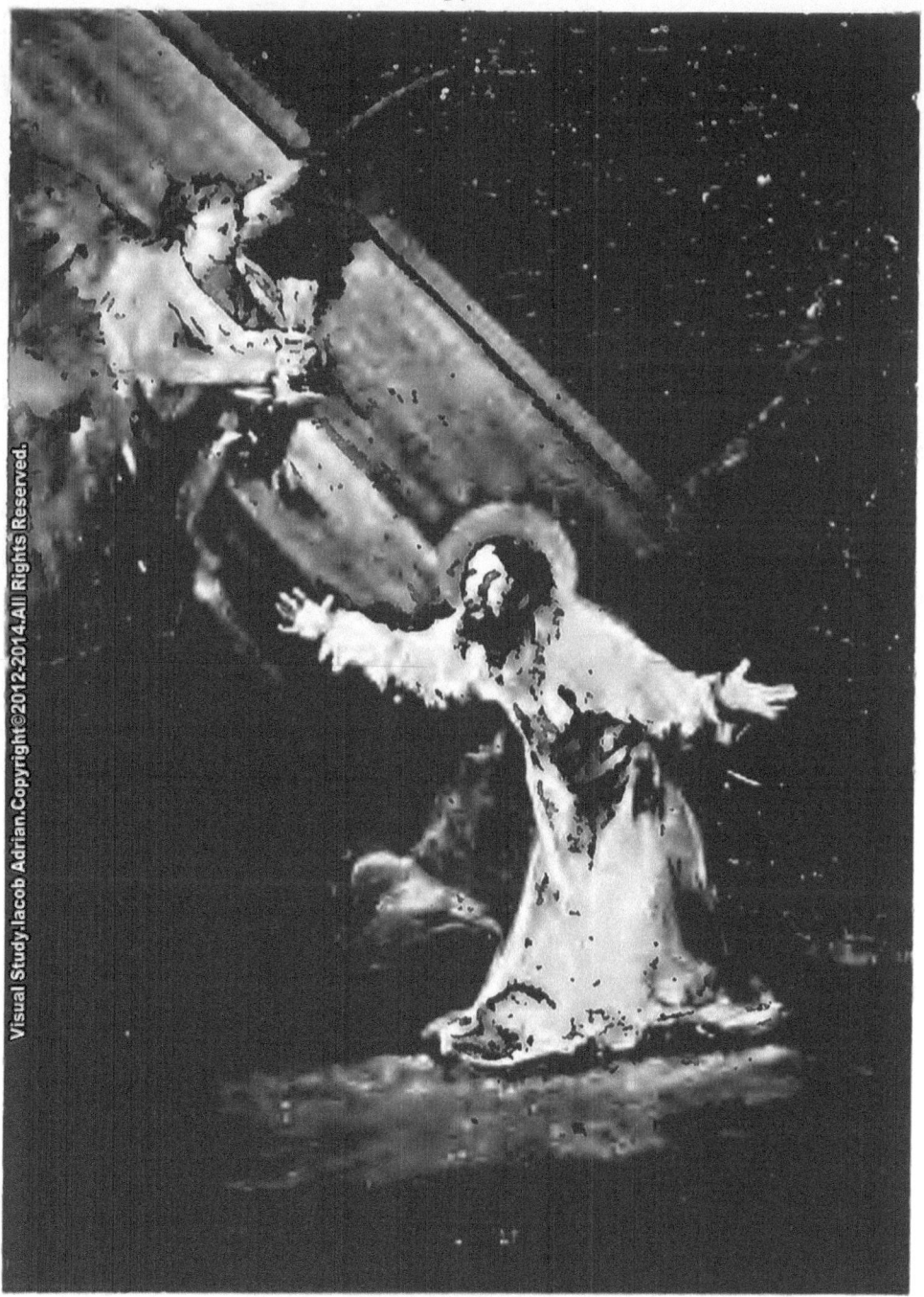

CHRIST PRAYING AT GETHSEMANE CHRISTI GEBET AM ÖLBERG LA PRIÈRE DE JÉSUS A GETHSÉMANI
(El Rector de San Antón)
M. Moreno, Photo.

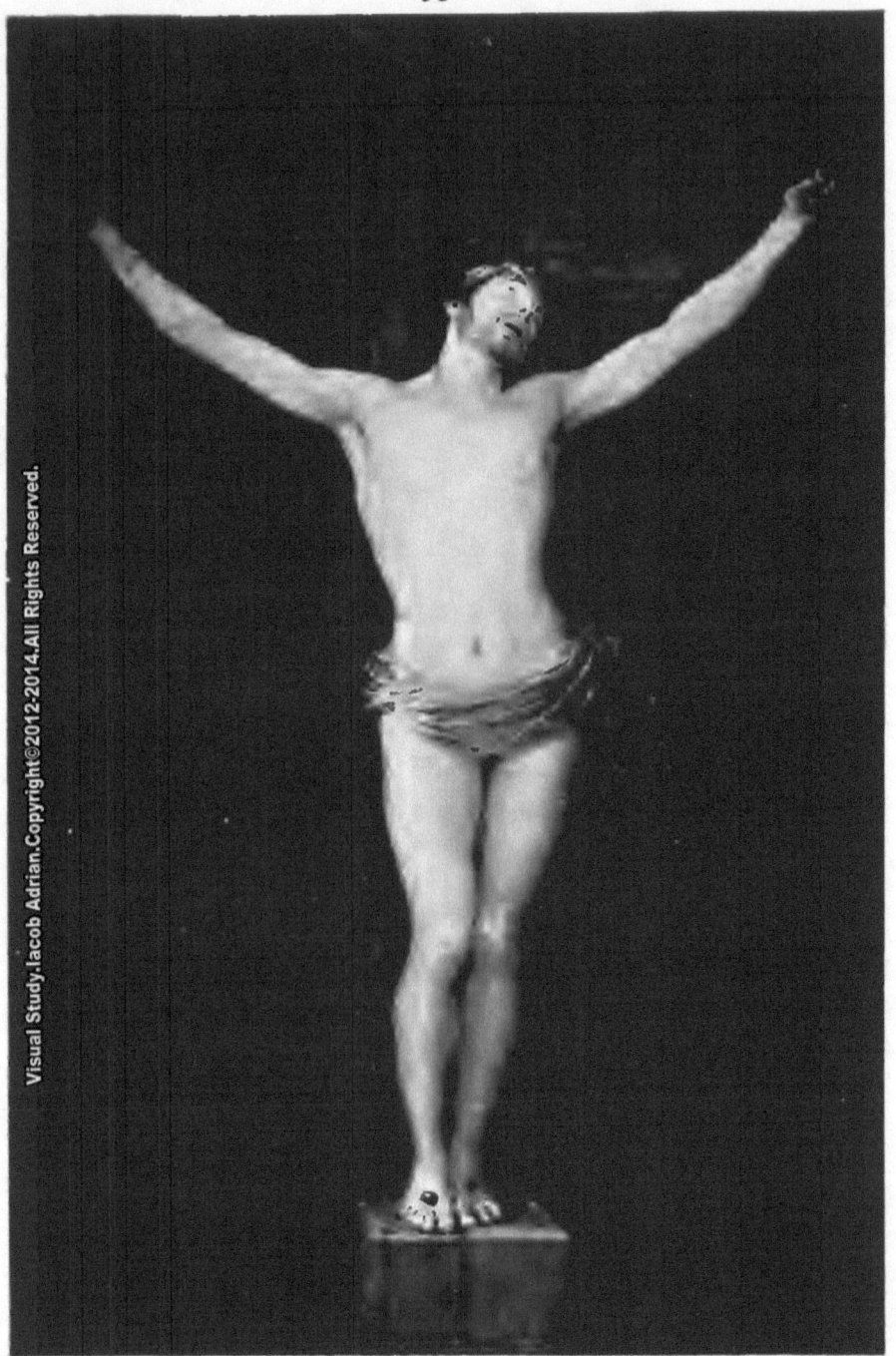

CHRIST ON THE CROSS (*Prado, Madrid*) LE CHRIST SUR LA CROIX (*Prado, Madrid*)
CHRISTUS AM KREUZ (*Madrid, Prado*)
F. Hanfstaengl, Photo.

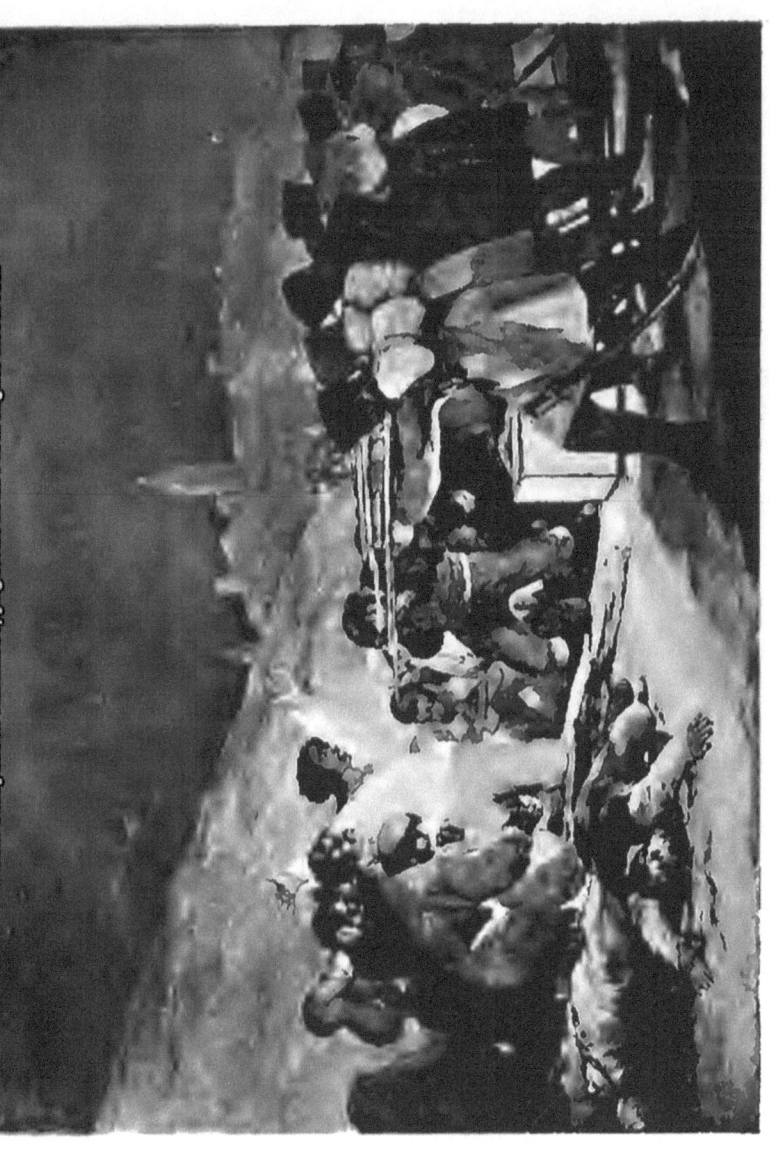

An Episode of May 3rd, 1808 Un Épisode du 3 Mai 1808
(Prado, Madrid) (Prado, Madrid)
Eine Episode des 3. Mai 1808 F. Hanfstaengl, Photo
(Madrid, Prado)

Bibliographic sources :

The masterpieces of Goya, 1746-1828 (1909)

Author: Goya, Francisco, 1746-1828

Publisher: London, Gowans & Gray

This documentary study use,
combined in various proportions,
elements from the following categories,
forms and subsets :
- fair use
- documentary
- documentary photography
- feature
- journalism
- arts journalism
- visual journalism
- photojournalism
- celebrity photography
in order to :
- employ material as the object of cultural critique ,
- quote to illustrate an argument or point ,
- use material in historical sequence,
providing independent opinion,
using photos, press articles, advertisements,
opinions of fans etc. ...

Copyright©2012-2014 Iacob Adrian
All Rights Reserved.

www.ingramcontent.com/pod-product-compliance
Lightning Source LLC
Chambersburg PA
CBHW021022180526
45163CB00005B/2068